IMAGES
of Rail

SLABTOWN STREETCARS

Six of the long-lasting streetcar lines that served Slabtown and Northwest Portland are seen in this detail from the 1920 Pittmon City Map. They include Sixteenth Avenue (1889–1937), Twenty-Third Avenue (1891–1950), North and South Portland (1900–1937), Depot and Morrison (1907–1923), Kings Heights (1911–1941), and Westover (1913–1941). The Willamette Heights Line is absent because it did not begin until 1923. (The "W" on the map marks the Depot and Morrison Line.) (Author's collection.)

ON THE COVER: Sixteenth Street Line Car No. 317, seen heading north on Northwest Nineteenth Street in 1907, is field testing an Eclipse Lifeguard safety fender designed to scoop up anyone who fell in front of a streetcar. No. 317 was a Fuller "Standard," built in the Portland Railway Company shops at Northwest Twenty-Third Avenue and West Burnside Street. The poster on the dash advertises the Whang Ho Pirate Chase ride at Oaks Park. (Author's collection.)

IMAGES
of Rail
SLABTOWN STREETCARS

Richard Thompson

ARCADIA
PUBLISHING

Copyright © 2015 by Richard Thompson
ISBN 978-1-4671-3355-5

Published by Arcadia Publishing
Charleston, South Carolina

Printed in the United States of America

Library of Congress Control Number: 2015930226

For all general information, please contact Arcadia Publishing:
Telephone 843-853-2070
Fax 843-853-0044
E-mail sales@arcadiapublishing.com
For customer service and orders:
Toll-Free 1-888-313-2665

Visit us on the Internet at www.arcadiapublishing.com

*This book is dedicated to my mother,
Barbara Webb Thompson (1912–1980).*

Contents

Acknowledgments		6
Introduction		7
1.	From Horsecars to Trolleys	9
2.	A Tale of Two Barns	21
3.	The Sixteenth Street Line	43
4.	The Twenty-Third Street Line	53
5.	The Willamette Heights Line	71
6.	Stubs and Crosstown Lines	93
7.	Streetcars Return to Slabtown	115
Index		127

Acknowledgments

I wish to thank history enthusiasts Norm Gholston, Mark Gilmore, Dan Haneckow, Ken Hawkins, Wayne Jones, Mark Kavanagh, Mark Moore, Steve Morgan, Don Nelson, Jerry Risberg, and the late Mike Ryerson for sharing images, and knowledge, from their collections.

I also wish to recognize Bill Failing and Dan Volkmer for helping me locate facts and photographs needed for this latest project.

I am very grateful to Wayne Jones and Mark Kavanagh for proofreading the manuscript; to Norm Gholston for fact-checking; and to my partner, Jan Hofmann; and my editor at Arcadia Publishing, Mathew Todd, for help with layouts and planning.

In addition, I want to acknowledge the encouragement and mentorship received from my late friends William K. "Bill" Hayes, G. Charles "Chuck" Bukowsky, and John T. Labbe during the 30 years spent gathering the materials used in my books.

Unless otherwise noted, all images in this book are from the author's personal collection, including those from issues of the *Street Railway Journal* and those taken by a photographer identified only as McClellan. Original photographers are cited wherever possible. Further information can be found on the author's website, vintagetrolleys.com.

Introduction

Slabtown is a neighborhood in Portland, Oregon, bounded by Northwest Lovejoy Street, the Tualatin Mountains (known locally as the West Hills), Northwest Nicolai Street, and the Willamette River. In the early 1900s, it extended at least as far south as Northwest Glisan Street. Almost from the start, its history has been closely intertwined with streetcars.

Activity in Slabtown dates from well before the arrival of European settlers. It was home to Native Americans, who conducted a thriving trading center in the area before it succumbed to competition from the Hudson's Bay Company. Until it was filled in for streetcar-line-hugging developments, much of Northwest Portland, including Slabtown, consisted of wetlands, lakes, gullies, and creeks.

During the 19th century, areas of town above B (present-day West Burnside) Street were variously known as the West End, the North End, or just North Portland. That usage began to change when streets were renamed following the merger of the cities of Albina, East Portland, and Portland in 1891, and it was finally put to rest by the "Great Renumbering" of 1933. What had been North Portland was designated Northwest Portland, and North Portland addresses were now located on the other side of the Willamette River.

Slabtown began as a self-contained neighborhood of modest homes clustered around Northwest Twenty-Third Avenue and Thurman Street. It was a community replete with hotels, restaurants, bars, grocery stores, bakeries, and other small businesses, most of which catered to employees from nearby mills, factories, and streetcar carbarns. In the early 20th century, a wave of workers from Croatia, Ireland, and Italy took up residence in Slabtown apartments and boardinghouses.

Slabtown got its unusual name during the 1870s, when the George Weidler Lumber Mill on Northrup Street began marketing slab wood as fuel. As other northwest lumber mills followed suit, homes and businesses began heating with this inexpensive byproduct created when logs were squared to make lumber. Wood was delivered in four-foot sections that could be cut into furnace-size pieces and stored in basements. When stacked along the street to cure, it created block-long "tunnels" that left a lasting impression on those walking, or riding a streetcar, through a town of slabs.

No other part of the city had as many connections to street railway history as Northwest Portland and Slabtown, which owe much of their development to the arrival of streetcars. This region was home to the city's first streetcar line, the first carbarn, the first streetcar manufacturing factory on the West Coast, and the city's last trolley line. Slabtown streetcars served a more diverse area than elsewhere in town, carrying passengers from residential neighborhoods to schools, churches, parks, hospitals, medical schools, shopping districts, restaurants, hotels, movie theaters, industrial areas, two breweries, an ice arena, and a cemetery.

During the horsecar days, no fewer than three street railway companies carried riders through Northwest Portland. By the time the streetcar lines in Northwest Portland had been converted to electric operation in 1892, two remaining railway companies were competing fiercely. Eventually,

streetcars for all seven of the lines that served Northwest Portland were stored at the Savier Street Carbarn in Slabtown.

Competition proved beneficial to the local economy when streetcar manufacturing centers developed at opposite ends of Northwest Twenty-Third Avenue. One of them was located in Northwest Portland, and the other was one block south, on West Burnside Street, in Southwest Portland.

In 1883, Slabtown's North Pacific Manufacturing Company became the first enterprise in the Western United States to build streetcars. These homemade streetcars were horse-drawn, but in 1891, faced with delays in acquiring new-fangled electric streetcars from national builders, the City & Suburban Railway Company began producing its own trolleys at the Savier Street Carbarn. Its initial efforts involved splicing together former horsecar bodies. In 1899, the nearby Hand Manufacturing Company expanded upon this concept by utilizing old horsecars to create combination open and closed trolleys that were over five feet longer.

The recycling of older car bodies was no longer necessary by 1901, when complete streetcars were being built from start to finish by the City & Suburban Railway and Portland Railway companies. The unique designs developed by Portland Railway president Franklin Fuller, in particular, garnered national attention.

Before older rolling stock was retired during the 1910s, the number of locally built streetcars on the railway company roster reached 54 percent. National car builders did not begin filling orders for more than 10 streetcars until 1907. PAYE (pay-as-you-enter) trolleys from the American Car Company in St. Louis began making inroads after that, soon becoming ubiquitous here. Yet, even after the influx of trolleys from back East, nearly one-third of all streetcars in Portland were locally manufactured.

Slabtown's most-visited sites were made possible by streetcars. Most of the 1.2 million people who attended the Lewis and Clark Centennial Exposition during the summer of 1905 arrived by streetcar. Four trolley lines had been rerouted to use new loop tracks adjacent to the fairgrounds, and it is said that a streetcar passed by the entrance gates every 30 seconds. Until the Great Depression, the former fairgrounds continued to be an attraction for tourists riding the "Seeing Portland" tour trolley.

Many visitors were so impressed by the whole experience that they chose to move here. In the five years following the exposition, the population of Portland grew from 161,000 to 270,000. Real estate interests responded with new housing developments in Slabtown.

Streetcars were also responsible for Slabtown's other big attraction, the Vaughn Street Ballpark, which was financed in 1901 by Portland Railway president Franklin Fuller and City & Suburban Railway treasurer Charles Swigert. These open-minded officials hoped to increase ridership for their companies, both of which had lines passing near the ballpark, while also earning money at the turnstiles. History proved them right, and the ballpark was home to the Pacific Coast League Portland Beavers until it closed in 1956.

After the rival railway companies merged in 1904, Charles Swigert turned to new endeavors, including the Portland Bronze and Crucible Steel Company, which made wheels, gears, and other metal parts for streetcars. In 1913, he founded the Electric Steel Foundry (ESCO), a company that remains a Slabtown institution. Meanwhile, Franklin Fuller continued in the railway business, becoming a vice president of the Portland Railway, Light & Power Company.

After the rumble of streetcars disappeared in the post–World War II years, the name Slabtown was largely forgotten, and the area stagnated. Today, however, the neighborhood is undergoing revitalization, as industrial sites dwindle and new apartments and condominiums join restored Victorian homes. Since 2001, modern streetcars have glided past new stores, restaurants, coffeehouses, and brewpubs along Northwest Twenty-Third Avenue, reasserting the trolley's role in Slabtown transportation.

One

FROM HORSECARS TO TROLLEYS

The first streetcar line in Oregon began service to the southern edge of Slabtown in 1872 when entrepreneur Ben Holladay, who had gained fame and fortune creating the Overland Stage to California during the Gold Rush, opened the Portland Street Railway. His horse-drawn streetcars ran through the Southwest Portland business district to a terminus at Northwest First and Glisan Streets. The new horsecars proved to be the most comfortable way to travel on streets not yet paved with cobblestones.

The First Street Line enjoyed a transit monopoly until 1883, when the streetcars of two competing companies finally reached the heart of Slabtown. That July, the Multnomah Street Railway Company, backed by money from the Amos King family and George Weidler, opened a branch line running up what is now Northwest Sixteenth Avenue to S (Savier) Street. That same year, the competing Transcontinental Street Railway Company, managed by William S. Ladd and Henry W. Corbett, opened the Hospital Line on G (Glisan) Street and the S Line on Thirteenth Street (now Fourteenth Avenue) to S Street. By 1887, the S Line had been extended westward to Twenty-Sixth Avenue.

As the 1890s dawned, local streetcar companies began converting their lines from old-fashioned horse power to electric trolleys. The Portland Street Railway never made that move, having languished under the poor management of Ben Holladay's brother Joe. By the time it went bankrupt in 1895, it enjoyed the distinction of having been both Portland's first and last horse-drawn streetcar operation.

The first trolleys began running along Slabtown streets during the winter of 1890–1891 when the Multnomah Street Railway's Fifteenth Street Line (the street would soon be renamed Sixteenth) was electrified. In September 1891, a new electric branch opened on the future Northwest Twenty-Third Avenue. When rival Transcontinental Street Railway followed suit in April 1892, Slabtown gained two more trolley routes, on G and S Streets. Commercial development grew along these transportation corridors, as did new homes, apartments, and hotels clustered around streetcar terminals on Northwest Thurman Street.

In this c. 1884 view, a Portland Street Railway horsecar is plodding past the cast iron-fronted buildings along Southwest First Street in what is now the Skidmore Fountain area. The tower of the Kamm Building in the distance helps date the picture. Although this is not in Northwest Portland, it is very close; the streetcar crossed West Burnside Street in one block. Trolley wires will soon join the myriad of telephone and electric lines overhead. (Courtesy Norm Gholston.)

This photograph, taken during the Great Flood of 1894, looks south from the intersection of Northwest First and Glisan Streets. Portland's first carbarn, fronting on Northwest Flanders Street, can be seen to the left. By this time, it housed only two streetcars and four horses, the minimum amount of equipment needed to hold the Portland Railway Company's First Street Line franchise.

The Portland Street Railway gained competition when the Multnomah Street Railway opened the Washington Street Line in November 1882. No. 1 is ready to depart the carbarn on Southwest Sixteenth and Washington Streets for the run to Slabtown on the new Washington, B & 15 Streets branch. The line had been intended for one-horse operation, but the Burnside Street grade proved too steep. (Courtesy Mark Moore.)

MULTNOMAH STREET RAILWAY
Portland's Second Streetcar Company

KEY

- 13th St. Line (Nov. 1882)
- 16th St. Line (July 1883)
- Washington St. Line (to 22nd, Dec. 1883, soon extended to St. Clair because of difficulty of holding cars on Burnside grade)
- Extension to City Park and Gambrinus Beer Garden (1886)
- Associated Portland Traction Co. line on 2nd St. (1888), sold within one year to Metropolitan St. Ry., which replaced line with standard gauge interurban to Fulton Park.

This map, based on a 1960 sketch by David L. Stearns, shows the horsecar lines of Portland's second streetcar company, the Multnomah Street Railway Company, in the 1880s. Also shown is the line of the Portland Traction Company, which would take over the Multnomah operation in 1888. Routes were indicated by colored-glass circles at each end of the Bombay roofs: green for the Washington Street Line, salmon for the Thirteenth Street Line, and blue for the Sixteenth Street Line. The Sixteenth Street Line was the first streetcar line to reach into the heart of Slabtown.

Portland Iron Works employees pose with S Street Line horsecar No. 14 on what is now Northwest Fourteenth Avenue and Northrup Street soon after the Transcontinental Street Railway inaugurated Portland's third street railway company in 1883. The Transcontinental system included two branches serving Northwest Portland: the G Street and S Street Lines. Portland's last three new horsecars opened the westward extension along S (Savier) Street in 1889. (Courtesy Norm Gholston.)

Transcontinental Street Railway horsecar No. 15 is crossing Northwest Lovejoy Street southbound on what is now Northwest Fourteenth Avenue. It is on the S Street Line and, as indicated by the letter board above the windows, will continue along Third and G Streets. The Portland Cordage Company factory in the background, which manufactured ropes for sailing ships, is part of Bridgeport Brewing today.

No. 17, one of the first trolleys to serve Slabtown, arrived from builder J.G. Brill in 1890. It is seen here a few years later on the Twenty-Third Street Line. The residential background suggests that it is near Thurman Street, since lower Twenty-Third Street was more commercial, containing Gambrinus (beer) Gardens, corrals and feedlots, nurseries, a former slaughterhouse, and Good Samaritan Hospital. (Courtesy Norm Gholston.)

This trolley at Northwest Twenty-Second and Glisan Streets is a G-Hospital Line student shuttle. Multnomah Street Railway ordered six Low's Adjustables from the Stockton Combine, Harvester and Agricultural Works in 1890, thinking them ideally suited to Portland weather. They featured longitudinal bench seats that could be flipped inwards in cold weather or outwards when it was hot. This one had been modernized with portable vestibules to protect motormen.

No. 37 was pressed into service soon after it arrived from the Stockton Combine, Harvester and Agricultural Works in April 1891. It is seen here, during the Portland Railway years, at the Sixteenth Street Line terminus on Northwest Twenty-First and Reed Streets next to a new store selling tobacco, candy, and nuts. The firehouse in the background housed steam pump engine No. 6 and a hose wagon. (Courtesy Mark Moore.)

Motorman Jack Workman, seen at the helm of No. 38 at Northwest Sixteenth and Davis Streets in the summer of 1895, described this as Portland's first open car, but he likely meant the first open on the Sixteenth Street Line. However, it was actually one of the Low's Convertibles remodeled into a permanent open car after the conversion process was found to be too cumbersome.

In 1892, the Multnomah Street Railway augmented its fleet with another order from the J.G. Brill Company, this time for six "long cars" sporting type 11B Maximum Traction trucks. These closed 34-foot-long trolleys could accommodate more passengers and were better suited to winter service. Within a year, they had been transferred to North Portland for service on the Vancouver Line. (Courtesy Mark Moore.)

The first electric streetcar lines serving Slabtown are represented with dashed lines on this detail from the Official Map of the City of Portland, published by Habersham, Nieberding and Tarbet in 1891. Those reaching Slabtown ran along North Twenty-Second (now Northwest Twenty-Third), North S (now Northwest Savier), North Fifteenth (now Northwest Sixteenth), North Thirteenth (now Northwest Fourteenth), and North G (now Northwest Glisan) Streets.

The arrival of the electric streetcar in Slabtown was followed by what was possibly the first trolley-related fatality in Portland. On November 12, 1892, six-year-old Mary Bodli died when she fell beneath an S Line streetcar at Northwest Nineteenth and Savier Streets. Motorman H.E. Howard, who was starting forward after making a stop, said she fell toward the middle of the car after the forward trucks had gone past.

WAS INSTANTLY KILLED

Little Mary Bodli Crushed Under a Car.

MOST DEPLORABLE ACCIDENT

She Fell and Was Caught Between the Trucks.

WHAT THE MOTORMAN CLAIMS

Henry Neighten's Story of the Shocking Casualty—The Coroner Will Make an Investigation Tomorrow.

The car involved in the accident was the pride of the City & Suburban fleet when delivered in April 1892. The 25 new Pullmans were described by the *Oregonian*: "They have sides running up and down like railroad cars, and are painted white, ornamented with dark brown striping and gilt flourishes, which gives them a very handsome appearance." The siding reference meant no curved rocker panels below the windows.

PORTLAND CONSOLIDATED ST. RY. CO.
NOT TRANSFERABLE.

COMPLIMENTARY.

Good for One Fare as per Conditions on cover.

Portland's 12 street railway companies began consolidating in the early 1890s. One of the first mergers created the short-lived Portland Consolidated Street Railway Company (1892–1894), which included the Multnomah Street Railway, the Metropolitan Railroad, and the street railway in Vancouver, Washington. Unfortunately, entrepreneur George B. Markle's ambitious trolley empire failed in the financial Panic of 1893. (Courtesy Mark Moore.)

By 1902, two remaining street railway companies operated 23 lines. The City & Suburban Railway and the Portland Railway had survived the Panic of 1893 to enjoy a healthy competition, although this resulted in some inefficient parallel routes. As shown on the cover of this directory, trolleys usually went past their corporate headquarters on either Southwest Third and Morrison Sreets or First and Washington Streets downtown.

In 1906, a syndicate of New York and Philadelphia banks consolidated most street railway and electric power companies in the region to form the Portland Railway, Light & Power (PRL&P) Company. Eastern investors were now at the helm in Albany, Corvallis, Eugene, Oregon City, Salem, Silverton, Mount Angel, Portland, and Woodburn.

A PRL&P 4.5¢ fare commutation ticket is pictured here. Tickets like this offered a half-cent discount when purchased in booklets of 60. This concept was introduced in 1894 as street railway companies began to consolidate. Before that time, those needing to ride two or three different lines to reach a destination paid an additional 5¢ on each streetcar because no transfers were issued between competing companies.

19

```
                              Portland
                           Street Railway
                            (1872-1895)

Multnomah          Multnomah         City & West      Barnes Pk. Hts.    Thomson
Street Railway     Railway           Portland Park    & Cornell Mt.      Houston Elec.
(1882-1888)        (1882-1888)       (1889-1901)      (1890-1896)        (1891)

Portland           Oregon Land       Transcontinental  Willamette         Waverly-
Traction (OR)      & Investment      Street Railway  → Bridge Railway ←   Woodstock Elec.
(1887-1889)        (1888-1892)       (1882-1891)       (1887-1891)        (1891)

Portland Ht.'s     Metropolitan      George B.         Portland &                          Portland, Mt.
Transfer           Railway           Markle          ← Vancouver Ry.                       Tabor & Eastern
(1882-1888)        (1889-1892)       1892              (1888-1892)                         (1892)

Portland Cable     Portland Cons.    Columbia Land                                         Portland &
Railway            Street Railway    & Imp. (WA)                                           Suburban Ry.
(1887-1892)        (1892-1894)       (1888-1893)                                           (1903)

City Cable         C. F. Paxton      Metropolitan                                          George W.
(Fuller, Rec.)     Receiver          Railroad                                              Brown
(1892-1894)        (1892-1896)       (1896-1900)                                           (1888)

Portland           Portland                                                                Mt. Tabor St.
Traction (CA)      Railway (1st)                                                           Railway
(1894-1900)        (1896-1900)                                                             (1889-1892)

   Portland          Portland              City &              East Side
   Railway (2nd)     Consolidated Ry. ←    Suburban Ry.        Railway
   (1900-1904)       (1904-1905)           (1891-1904)         (1891-1893)

   Portland &                              Portland, Chicago   In
   Fairview R.R.                           & Mt. Scott Ry.     Receivership
   (1890-1904)                             (1891-1901)         (1893-1900)

Portland &         Portland, Vancouver  Portland              Portland City       Oregon City &
St. Johns Ry.    → & St. Johns Ry.    → Railway (3rd)         & Oregon Ry.    ←   Southern Ry.
(1903-1905)        (1905)               (1905-1906)           (1901-1902)         (1901-1902)

                                                              Oregon Water
                                                              Power & Ry.
                                                              (1902-1907)

                          Portland Ry.,
                          Light & Power
                          (1906-1924)
```

41 companies, or receivers, operated street and interurban railways in Portland and vicinity between 1872, when the first line opened, and 1906, when the Portland Railway, Light & Power Company consolidated all electric railways in the largest merger in Oregon history. PRL&P managed Portland's streetcars through the peak years, overseeing a trolley empire that, with 583 passenger motorcars and 347 miles of track, included interurban lines, sidings, and double track. There were 172 miles of track in the city. The company began with 23 city streetcar lines in 1906 and reached a high of 43 lines in 1915. The number of streetcar lines did not begin to fall until after PRL&P was reorganized as the Portland Electric Power Company (PEPCO) in 1924. Just 15 streetcar lines remained after many lines were converted to bus under the terms of the 1936 franchise. By the time all city streetcar service was discontinued in 1950, only three lines remained.

Two
A Tale of Two Barns

The craft of streetcar building was nowhere more evident than in Slabtown. While it is true that streetcars were built in other parts of town, those were interurbans or remodeled older trolleys. Until 1910, the majority of Portland's streetcars were the products of two carbarns located at opposite ends of Northwest Twenty-Third Avenue. The one at the southern end of Twenty-Third Avenue was in Southwest Portland, so it is hoped that readers will grant the author poetic license in describing this as being "close" to Slabtown.

Portland's two rival street railway companies, the City & Suburban Railway and the Portland Railway, turned to manufacturing streetcars out of necessity. They faced a shortage of rolling stock when national car builders were unable to keep up with the growing demand.

In addition to railway shops, Slabtown held the distinction of housing two independent companies connected with the streetcar business. In 1883, North Pacific Manufacturing became the first company on the entire Pacific coast to build streetcars. This pioneering effort was followed, around 1905, by the Portland Bronze and Crucible Steel Company, which opened the first steel casting plant in the West to supply wheels, gears, and other metal parts for streetcars.

The Transcontinental Street Railway Company began construction of the Savier Street Carbarn between Northwest Twenty-third and Twenty-Fourth Avenues on Savier Street in 1887. Successor companies made additions to the carbarn complex, including an office, clubhouse, foundry, and additional bays, in 1891, 1906, and 1909. The Savier Street Carbarn closed in 1938.

The Multnomah Street Railway started work on the Washington Street Carbarn at the intersection of West Burnside and Twenty-Third Streets in November 1891. The Portland Railway Company augmented the original carbarns with an unusual two-story shop in 1902. Successor PRL&P used the shop until 1912.

No traces of these two historic carbarns remain today. The area along West Burnside Street on the corner of Twenty-Third, where the Washington Street Carbarn was located, is largely given over to a grocery store parking lot now, and the Savier Street site houses condominium residents rather than streetcars.

In 1883, the North Pacific Manufacturing Company expanded its line of carriages, buggies, trucks, drays, and agricultural implements to include the first streetcars built on the Pacific coast. The factory, on the corner of Northwest Twenty-Second and T Streets (now Twenty-Third and Thurman), continued to produce handsome horse-drawn streetcars until the death of proprietor Wesley Jackson in 1891. (Courtesy Norm Gholston.)

Amidst the rolling stock lined up in front of the Multnomah Street Railway carbarn on Southwest Fifteenth and Washington Streets are several of the first horsecars manufactured on the Pacific coast. They were made by the North Pacific Manufacturing Company in nearby Slabtown. The building under construction in the background is Portland High School, which opened in 1885.

When Wesley Jackson died in 1891, his partner, Charles B. Hand, took over the business and moved it several blocks to the corner of Northwest Nineteenth and Vaughn Streets. The renamed Hand Manufacturing Company expanded its offerings to include electric streetcars. (*Street Railway Journal*.)

Hand Manufacturing built car No. 52 for the Portland Consolidated Street Railway Company in 1893. This single truck trolley has evolved considerably from the earlier horsecars, featuring enclosed platforms and a longer, seven-window body. The location of this photograph is unknown, but it may have been taken near the Southwest Second and Alder Street terminal for the Alberta Street Line. The sign on the shack at left is for Northwest Bridge Works Contractors. (Courtesy Mark Moore.)

No. 78, one of three cars built for the City & Suburban Railway in 1899, was one of the last streetcars made by the Hand Manufacturing Company. Known as a "California" car, its half-open-half-closed body was created by splicing together two horsecars. It is seen at the Ankeny Carbarn next to Kern Elementary School on Northeast Twenty-Eight Avenue and Couch Street during the Portland Consolidated Railway years (1904–1905).

This view shows the interior details of car No. 78, including the large metal fare register and advertisements for the Oregon Railroad & Navigation Company (OR&N), Grape Nuts, and Knabe pianos. The slat floor was designed for easy cleaning, since dirt fell between the boards. These three "all-weather" cars may have been popular with riders, but not with management, which retired them in 1917.

24

The Washington Street Carbarn included a new shop on Ford (now Southwest Vista) Street and two older tin-clad carbarns. Shops for painting, armature winding, blacksmithing, woodworking, and machining can be seen as well as nearby stores, homes, and boardinghouses. Rails added to this detail from the 1908 Sanborn Insurance Map show ladder tracks on Washington (now West Burnside) Street and the siding at City Park.

These streetcars in one of the older Washington Street Carbarns were locally built or remodeled. The car at right is a combination cable car and trolley, created in 1896 by the Portland Traction Company, which mounted motorized trucks on one end of a cable car while leaving the grip mechanism on the other end. The trolley at far left was made by the Hand Manufacturing Company.

The new shop building at the Washington Street Carbarn is seen here shortly after completion by the Portland Railway Company in 1902. The carbarn complex was so named because, until 1933, the portion of Burnside Street west of Sixteenth was an extension of Washington Street. The facility expanded and modernized an existing carbarn, shop, and powerhouse complex begun by the Multnomah Street Railway in 1891. (*Street Railway Journal*.)

The 1902 shops at the Washington Street Carbarn were fully equipped. Well-lit by skylights and windows, the second-floor woodworking shop included a ripsaw, sticker, planer, combination saw, mortiser, sander, shaper, boring machine, pattern lathe, band saw, and dado saw. Two large Sprague motors supplied power for the belt drives. (*Street Railway Journal*.)

Franklin Fuller's career is synonymous with the history of Portland street railways. As receiver, he guided the Portland Cable Railway through the Panic of 1893. When he became manager of Portland Traction in 1896, he began converting from cable to electric operation. As president of Portland Railway and then Portland Consolidated Railway, he implemented the large mergers. When Fuller passed away in 1925, he was a PRL&P vice president.

Franklin Fuller's moment of glory came in 1902 when, as president of the Portland Railway Company, he helped design a new type of locally built streetcar. The three-compartment cars featured enlarged platforms, which were welcomed by smokers, who were prohibited from smoking in the main section of a streetcar by city ordinance. Fuller Standard No. 116 is seen here in front of one of the Gambrinus Brewing Company buildings. (*Street Railway Journal*.)

The enlarged end platforms, or vestibules, featured on Fuller Standard trolleys are evident in this view of four Fullers nearing completion. The erecting and paint shops were on the first floor, and the woodworking shop was on the second. Car bodies were hoisted between locations in a unique 40-by-10-foot streetcar elevator. (*Street Railway Journal.*)

The Toronto-style streetcar in the distance (named after a Canadian car that served as a model for this design) is starting on the journey to Kings Heights or Arlington Heights in this c. 1913 scene looking west on Burnside Street from Southwest Vista Avenue. The Gambrinus Brewing Company tavern is on the right, and the then recently closed Washington Street Shops are on the left. The older carbarns behind it would be razed by the 1920s, and the shops themselves demolished in 1934.

This photograph was taken next to the bays of the Washington Street Carbarn around 1912. In that year, lumberman Simon Benson donated $10,000 for the purchase and installation of 20 Benson Bubbler drinking fountains, such as the one seen here. The coin-operated scale at far left was on the corner of the building housing the Keystone Ice Cream Parlor and Portland Consolidated Railway ticket office.

PRL&P sold the Washington Street Carbarn after its Center Street Shops opened in 1912. It became the Washington Park Garage, which did a good business at a time when many homes lacked automobile parking. This picture was taken in 1933, a year before the former carbarn was razed. Murlark Hall, the building across the intersection housing the Edwin Robinson drugstore and a golf academy, was demolished in 1969.

One of PRL&P's first pay-as-you-enter (PAYE) streetcars is seen here being readied for operation at the Washington Street Carbarn. This large vestibule car is the kind of vehicle that began replacing locally built trolleys. It was one of 20, numbered 466–485, completed by the American Car Company on September 29, 1908. Note the clearly labeled entrance and exit doors.

No more "fares, please." Management liked the PAYE cars because rapid boarding kept things moving during rush hour; however, the new streetcars were not so popular with the riding public. As depicted in this 1909 cartoon from the *Portland Evening Telegram*, some felt they were rudely crammed as tight as sardines while waiting to pay their fares in the larger PAYE platforms.

The Savier Street Carbarn took up all of the block bounded by Northwest Twenty-Third, Raleigh, Twenty-Fourth, and Savier Streets, except for the Hotel Repose and a couple of houses (in the blank area to the right of the dashed line). Additions in 1891, 1906, and 1909 expanded the complex to include four bays (A, B, C, and D from left to right) and a storage yard. There were also offices, a clubhouse, and a small depot.

The building seen here is the original Transcontinental Street Railway Savier Street Carbarn, built in 1887 when horsecars reigned supreme. However, when this picture was taken on May 15, 1892, the last horsecar was waiting while new white-and-gold Pullman trolleys pulled into the barn. The streetcar manufacturing and repair shop at right replaced a stable. The house on the left was part of the complex for a time.

In 1891, the City & Suburban Railway built a two-story shop in the area that had originally housed the Transcontinental Street Railway stable. Nearly 100 streetcars were built here between 1891 and 1904. This picture, taken May 2, 1904, looks toward the southeast from the intersection of Northwest Savier Street and Twenty-Fourth Avenue. The odd-looking vehicle at lower left is a small electric locomotive.

Additions to the Savier Street Carbarn gave it a mix of styles. Bay D, at left, came last, in 1909. Bay C has been remodeled so that it bears little resemblance to its beginnings, as has Bay A, which included the clubhouse. Narrow, two-track Bay B in the middle is surmounted by a bay-windowed office.

This c. 1911 panorama, looking northeast toward the corner of what would now be Northwest Twenty-Fourth Avenue and Raleigh Street, provides a rare view of the back (Raleigh Street) side of the barn. Two trolleys can be seen in bays B and D. The latter is a Toronto built in the shops here in 1902. (Courtesy Donald R. Nelson.)

City & Suburban Railway carmen pose with their new Pullmans on the Northwest Raleigh Street side of the Savier Street Carbarn during the 1890s. These cars would soon be augmented by locally built trolleys. Note the pillbox-style hats, brass badges, and heavy double-breasted jackets (sensible attire for work on open platform cars like these). The colored-glass route indicators can be seen on the clerestory roofs.

Muddy Savier Street has not been improved, but the trolley has. The City & Suburban Railway modernized this 1891 vintage Pullman by enclosing the platforms and applying a new livery of red-and-yellow paint. The only person identified among the 19 men pictured here around 1904 is Herman Hanson, the tall motorman in the center (seventh from left).

Motorman Herman Hanson is sitting on the front porch of his home at 732 North Vaughn Street, six blocks from the Savier Carbarn. Most streetcar company employees lived close to their divisions in small homes or boardinghouses. The site where this little Victorian house once stood (2228 Northwest Vaughn after 1933) is now an empty field surrounded by the ramps for Highway 30.

This look inside the machine shop at the Savier Street Carbarn was taken in 1905, when car building and heavy maintenance were handled here. Lathes and drill presses are prominent amidst the organized clutter, with everything driven by large leather belts hanging from power take offs on the ceiling. Multiple light bulbs are suspended above each work station. The building also housed woodworking, paint, and blacksmith shops.

In addition to motormen and conductors, the Savier Street Carbarn employed a large shop crew as can be seen here. These 17 unsung heroes in aprons and overalls are posing with their supervisors in front of Bay C on Northwest Savier Street, the oldest part of the complex. The roof of a new white-and-gold Pullman can be seen in the background.

Repair and manufacturing facilities had been removed by the time this photograph was taken inside Bay A about 1911. PRL&P was about to open its Center Street Shops in Southeast Portland, which would replace shop facilities system wide. The trolleys in view, all signed for the North and South Portland Line, include Nos. 527, 465, and 465. The last two are Torontos, built in this very location in 1902.

Portland carbarns featured clubrooms where employees could relax after spending 10 or more hours on the job or while waiting to be given an assignment from the "extra board." This photograph of the Savier Street Clubhouse shows a well-equipped poolroom. (Courtesy Mark Gilmore.)

As orders from the major car builders became greatly delayed, the City & Suburban Railway Company came up with a local manufacturing solution that attracted national attention. In 1891, it began creating its own streetcars by splicing together old horsecar bodies. The hoods and platforms were removed from two Stephenson horsecars, and new floors and sills were added to form one larger trolley. (*Street Railway Journal*.)

Most of the spliced cars were assigned to North Portland, where this picture of City & Suburban Railway No. 44 was taken on Williams Avenue about 1891. Fifteen cars of this type were built at the Savier Street Carbarn. After the PRL&P consolidation, they were renumbered 151–165, and their platforms were enclosed, but their days were numbered. The first group of spliced cars was retired in 1910.

In 1901, the City & Suburban Railway Company began production of its Standard streetcars. 47 Standards were built in the company shops, making them the largest City & Suburban series. These handsome, high-riding cars remained in use on less traveled lines throughout the 1920s. No. 131 is seen here on Northwest Raleigh Street next to the Savier Street Carbarn.

The City & Suburban Railway built 16 of these open cars at Savier Street in 1903. Successor Portland Railway renumbered into the 200–215 series. No. 205 is seen here outside the carbarn on Northwest Raleigh and Twenty-Fourth Streets around 1913; it is still lettered for the Portland Railway. Due to their lack of windshields, they gained the nickname "Bald Face" cars. All of them were out of service by 1924.

The City & Suburban Railway built No. 300 as a touring car in 1904. The one-of-a-kind trolley named "Seeing Portland" departed Southwest Second and Morrison Streets twice a day for 2.5-hour trips past the city's scenic points. Highlights in Northwest Portland included Nob Hill, the Forestry Building, and Willamette Heights. After retirement in 1938, this heavy car was retained to clear tracks during snowstorms.

In 1902, the City & Suburban Railway turned from production of its Standards to a new type of car inspired by rival Portland Railway's Fuller cars. The 451–465 series were Torontos. The new three-compartment cars were very successful and most remained in use until the 1940s, although their removable side panels were permanently affixed after 1905.

39

After 1907, when they were able to satisfactorily handle large orders from PRL&P, national car builders began making inroads on locally built streetcars. The longitudinal bench seating then common on streetcars is clearly illustrated in this cross sectional drawing of American Car Company cars Nos. 466–485. It is easy to see why buses would be considered more comfortable in later years. Compare this with the interior picture on page 86.

144 streetcars of the type seen here were ordered from the American Car Company between 1909 and 1911. They could be found everywhere except the steepest hills, and quickly became the quintessential Portland streetcar. Their classic design featured omnibus-sided bodies, Maximum Traction trucks (in which the powered wheel is bigger than the other), and large pay-as-you-enter vestibules. This Multnomah County blueprint was redrawn by the author.

40

Shiny new car No. 610 is parked on Northwest Savier Street in front of the Savier Street Carbarn on a summer day in 1911. Among the last group of 15 American Car Company PAYE-type streetcars, it was 45 feet long and could accommodate 32 passengers on its longitudinal bench seats. The cars in this series remained in use until abandonment in 1950. (Courtesy Warren Wing.)

This photograph in the yard adjacent to the Savier Carbarn was taken around the time that division was closed. Several different trolley types are seen here, including Council Crest car No. 510, Toronto No. 464, and Willamette Heights Birney No. 19. As of October 23, 1938, all operating streetcars were transferred to the Ankeny Carbarn in Southeast Portland. (Courtesy Jerry Risberg.)

41

The streetcars are leaving. In this c. 1937 picture, the Savier Street Carbarn is being converted to use by trolleybuses. Double overhead wire has been installed, and an entrance onto Northwest Raleigh Street has been cut into the back wall of Bay A. The Third Street trolleybus line operated out of Savier Street Carbarn from May 23, 1937, to October 22, 1938, and then out of the Ankeny Carbarn until 1953.

The roll sign on the roof of Council Crest No. 501 says "CAR HOUSE," but it is not headed for the Savier Street Carbarn. This picture of car No. 501 gliding along Northwest Raleigh Street past former Bay D was taken during a 1940s fan trip, long after that carbarn had closed. (Photograph by Charles Hayden.)

Three

THE SIXTEENTH STREET LINE

In July 1883, the Sixteenth Street Line became the first streetcar route to directly serve Slabtown. It was the second line opened by the Multnomah Street Railway Company, whose system would center on Southwest Washington Street. Service began with the Washington Street Line on November 22, 1882. The initial franchise ran along Southwest Washington Street from Southwest First Street to B (present-day Burnside) Street, and out B Street to City Park, just west of present-day Northwest Twenty-Third Avenue.

The Sixteenth Street Line was the second of two branches added to the Washington Street System while the company was still a horse-powered enterprise (the first branch was in Southwest Portland). The line (technically, the Fifteenth Street Line before the renumbering of streets in 1891) originally operated between Southwest First and Washington Streets and Northwest Sixteenth and S (Savier) Streets.

The Washington Street Line was the first to convert from the more costly horsecar system to electric operation. Trolleys began running on newly double-tracked Washington Street on March 19, 1890, while horsecars continued to plod along the branches for eight more months. Electric streetcars made their first appearance in Slabtown when the Sixteenth Street Line was electrified on December 19, 1890.

The electrification of the Multnomah Street Railway was undertaken by the Sprague Electric Railway and Motor Company, founded by Frank J. Sprague in 1884. Sprague was gaining recognition for having installed the first successful large electric street railway system in the United States in Richmond, Virginia, in 1888.

The Sixteenth Street Line weathered the financial storm of the 1890s, continuing through subsequent operating companies. As Portland's street railways began to consolidate, the line was extended westward on Northwest Thurman Street to Twenty-Seventh Street. Northern extensions were added during the PRL&P years and the run later called the Sixteenth Avenue Line survived until it was converted to bus on May 21, 1937.

The Sixteenth Street Line began in 1883 as a Multnomah Street Railway horsecar line. It was electrified in 1891. In 1899, the Portland Railway Company extended the line to Northwest Twenty-Fourth and Thurman Streets. Around 1900, the northern end of the line was moved to the Northwest Sherlock and Nicolai Streets terminus later used by North and South Portland cars. During the Lewis and Clark Centennial Exposition, the Sixteenth Street Line was one of four lines rerouted to use the new fairground loop tracks. In 1909, when PRL&P combined the Fifth and Sixteenth Street Lines, Southwest Fifth and Sherman Streets became the southern terminus. A year later, another Northwest Portland adjustment made the northern terminus Northwest Twenty-First and Reed Streets. In 1916, the southern end of the line became a loop along Southwest Fifth and Sixth Streets. The Sixteenth Street Line disappeared between 1926 and 1932 when it was merged with the Williams Avenue Line in North Portland. However, in 1933, a revised Sixteenth Avenue Line was introduced with a new southern terminus at Southwest Eighteenth Avenue and Mill Street. The line was converted to bus in June 1937.

Portland Railway No. 27 was a Pullman ordered for the Washington Street Line in 1890. It is seen here at the Sixteenth Street terminus on dusty Sherlock Street during the late 1890s. The union stockyards, piles of drying lumber, and Oregon Railroad & Navigation Company tracks in the background are evidence of the growing industrial development above Slabtown. (Courtesy Mark Moore.)

No. 41 was a Low's convertible ordered from the Stockton Combine, Harvester and Agricultural Works of Stockton, California, in 1890. A building is under construction in the background and, like the previous picture, this view at the end of the Sixteenth Street Line shows stacks of drying lumber. The area north of Slabtown housed several sawmills and drying yards, including those of the North Pacific Lumber Company. (Courtesy Mark Moore.)

Streetcar Lines to the 1905 Lewis & Clark Centennial Exposition

- 23rd St. & Willamette Hts.
- 23rd St. & Fairgrounds
- 16th St. & Fairgrounds
- South Portland & Fairgrounds
- Morrison St. & Fairgrounds
- Trippers for above

During the summer of 1905, visitors to the Lewis and Clark Centennial Exposition were served by the street railway company that merged Portland's last two city streetcar companies. The new Portland Consolidated Railway Company rerouted four lines to use newly installed fairground loop tracks on Northwest Upshur between Twenty-Fifth and Twenty-Seventh Streets. To accommodate the 1.2 million visitors to the fair, a trolley from the Sixteenth Street, Twenty-Third Street, South Portland, or Morrison Street Lines went by the exposition gates every 30 seconds. Regularly scheduled streetcars were augmented by "trippers" (cars that only went part way along the line) sent directly from the nearby Savier Street Carbarn. The success of Oregon's only world's fair was in large part made possible by the timely deployment of electric streetcars, many of which had been built locally in anticipation of fairgoing crowds.

46

Passengers are disembarking from a Sixteenth Street and Fairgrounds trolley in front of the colonnaded gates to the Lewis and Clark Centennial Exposition during Portland Day, September 30, 1905. The grand-looking buildings in the background were temporary facades not intended for use after the fair, and few survive today. The fairground loop tracks, on the other hand, continued in use until Portland's last city trolleys stopped running 45 years later.

Sixteenth Street and Fairgrounds car No. 102 is awaiting Exposition passengers on Northwest Twenty-Sixth and Upshur Streets with no fewer than three carmen in attendance. The car, still in Portland Railway Company livery, is a Fuller open built at the Washington Street Carbarn in 1903. It was later enclosed.

This picture of Portland Railway car No. 102 was likely taken shortly before PRL&P took over management of Portland's streetcar lines in 1906. At that time, Sixteenth Street Line cars were still running down Northwest Thurman Street to turn around on the fairground loop tracks on Northwest Twenty-Seventh Street. No. 102, a City & Suburban Railway Standard built at the Savier shops in 1901, remained in service until 1937.

Two unidentified carmen pose with No. 478 around 1910 in front of the rooming house on Northwest Twenty-First and Reed Streets at the newly designated northern terminus of the Sixteenth Street Line. The conductor (left) is wearing a coin changer, and the gloved motorman is at right. As indicated by the ornate dash sign, their trolley is one of the new pay-as-you-enter type. (Courtesy Mark Moore.)

48

Sixteenth Street Line car No. 467 has just passed No. 475 and will soon cross into Northwest Portland in this picture taken on Southwest Washington Street between Southwest Thirteenth and Fourteenth Streets around 1910. These new PAYE cars are traversing a row of uptown hotels, including the Ramapo on the left and the Franklin and Ansonia on the right. Note the three-lamp streetlights.

Once resplendent in white and gold, No. 59 has been renumbered and repainted in a more pedestrian red-and-yellow PRL&P paint scheme. It is seen here on Sixteenth Street Line duty in Northwest Portland sporting Nelson fenders added in 1913. The Maximum Traction trucks are clearly in view. Note that, although platforms are now enclosed, accordion gates are being used for safety instead of doors.

49

Car No. 633, which arrived in the last big order from the American Car Company in St. Louis in 1911, was still new when this picture was taken on the Sixteenth Street Line. The sign on the dashboard advertises a masquerade at Oaks Rink. Costumed roller skating parties like this were popular at the time and were often held close to holidays (in this case Washington's birthday).

In this newspaper clipping, Sixteenth Street Line car No. 144 is seen loading passengers on Southwest Washington Street at Broadway. In the background are the Majestic and Star Theaters. The movie on the marquee, *The Sin Flood*, was a 1922 silent film starring Richard Dix.

50

A rider is clambering up the steps of a Sixteenth Street Line trolley in this photograph of car No. 537 looking north on Southwest Fifth Street between Morrison and Yamhill Streets on a waning 1920s day.

Conductors usually kept a pad of transfers for both outbound and inbound directions, as seen in these examples from the Sixteenth Avenue Line (renamed from Sixteenth Street in 1933), for northbound and southbound streetcars. The southbound transfers were "not good on westbound Twenty-Third car east of N.W. Sixteenth Ave." or "northbound N.S. Portland car east of N.W. 21st Ave."

After Portland Traction Company went to a one-man operation in April 1932, streetcars requiring two man crews stayed in the barn. Heavily patronized lines used converted PAYE cars, while the 200s (opens) and 300s (Fullers) were only seen on Ballpark or Rose Festival specials. The Sixteenth Avenue Line now used Birney safety cars like No. 9, seen here passing the Shell station on Northwest Sixteenth Avenue and Glisan Street.

During the Portland Traction years (1932–1950), streetcars needing repair were sent to the Center Street Shops, which had opened on Southeast Seventeenth Avenue in 1912. That is where this picture of Birney Safety Car No. 16 was taken after a collision with an automobile in the 1930s. It was repaired and returned to service on the Sixteenth Avenue or Willamette Heights Lines. (Photograph by Charles C. Snook.)

Four

THE TWENTY-THIRD STREET LINE

At the time of its demise on February 26, 1950, the Twenty-Third Street Line was the oldest operating carline in the city. Electric from the start, it opened in September 1891 as a branch of the Washington Street system begun by the Multnomah Street Railway. The Washington and Twenty-Third Streets streetcar ran on Twenty-Third Street from Southwest First and Washington Streets in downtown Portland to T (Thurman) Street in Slabtown. By September 1891, it was being extended into Willamette Heights.

Until a high, steel bridge was constructed in 1903, the western end of a trip was divided into two segments, with passengers for Willamette Heights having to walk across a wooden bridge spanning Balch Creek. The new Thurman Street Bridge accelerated development in Willamette Heights, particularly after the 1905 Lewis and Clark Centennial Exposition, and it remains in use today as Oregon's oldest bridge (albeit without trolley cars). During the summer of 1905, some Twenty-Third Street trolleys were routed past the Exposition entrance gates on Northwest Upshur Street.

In 1908, the Twenty-Third Street Line moved to a new terminus on Northwest Twenty-Fourth and Nicolai Streets in a rapidly developing industrial district, where it remained for nearly 30 years. Twenty-Third Street trolleys traded the large "W" signs on their dashboards to Depot and Morrison Street cars, which took over the task of carrying passengers bound for Willamette Heights.

The democracy of the streetcar was nowhere more evident than on the heavily traveled Twenty-Third Street Line, where well-to-do Nob Hill residents rubbed elbows with blue-collar workers on their way to long-ago landmarks like Murlark Hall, Gambrinus Brewery, the original Good Samaritan Hospital, and the Vaughn Street Ballpark. The line, renamed Twenty-Third Avenue (instead of Street) in 1933, would continue to traverse the heart of Slabtown for another 16 years.

Legend:
- 1882
- 1890
- 1891
- 1903
- 1905 & 37
- 1908
- 1926

The Twenty-Third Street Line began in the winter of 1890–1891 as a branch of the Multnomah Street Railway Company's Washington Street Line. By September 1891, the line had been extended out Northwest Thurman Street to Willamette Heights, although riders had to transfer to a second car on the opposite side of Balch Creek until the steel Thurman Street Bridge was completed in 1903. The line became the Twenty-Third Street and Willamette Heights Line until 1907, when the western end of the route was cut back to Northwest Twenty-Seventh Avenue and Depot and Morrison Line trolleys took over service to Willamette Heights. In 1908, the terminus was moved again, to Northwest Twenty-Fourth and Nicolai Streets in the industrial area above Slabtown. A new downtown loop became the southern terminus in 1926. Trolleys turned around on the Fairgrounds Loop from 1905 to 1907, and then again from 1937, giving the line a "dumbbell" configuration (with loops at both ends) a little over two miles in length. The Twenty-Third Avenue Line was converted to bus in 1950.

Twenty-Third Street and Willamette Heights car No. 125 is awaiting passengers on the fairground loop tracks then under construction on Northwest Upshur Street between Northwest Twenty-Seventh and Twenty-Fifth Streets. The dual-handled Fuller handbrake, visible through the front window, worked in a manner similar to the brakes in a cable car. These cars were built at the Washington Street Carbarn in 1902. (Courtesy Mark Moore.)

No. 245, seen on Northwest Thurman Street around 1904, was one of 11 center aisle Fuller open cars built at the Washington Street Carbarn in anticipation of Lewis and Clark Centennial Exposition crowds. When a 1907 ordinance forbade use of open cars in the winter, railway management enclosed the cars in this series. Unfortunately, they were soon dubbed "pneumonia cars" because the hasty remodeling had omitted bulkheads and seat heaters.

55

In December 1906, the recently incorporated Portland Railway, Light & Power Company was hit with a two-week strike. On the evening of Saturday, December 15, a group of strike sympathizers, frustrated by Vice Pres. Franklin I. Fuller's refusal to satisfy a union request for higher wages, attempted to stop trolleys from leaving carbarns. When their efforts met with limited success, they turned to violence. A "mob" at Northwest Twenty-Fourth and Thurman Streets jeered at crews on passing trolleys and someone threatened to kill motorman J.J. Coffey. Carmen who crossed the picket line were called "scabs" and were dragged from their cars and beaten. Demonstrators near railway headquarters in downtown Portland hurled rocks at loaded streetcars as they attempted to pass.

The car seen here at Northwest Thirty-Second and Thurman Streets gained the moniker "battle scarred 322" when every window was broken and the trucks (wheel sets) were damaged during strike demonstrations at the corner of Southwest Fifth and Washington Streets in downtown Portland on December 15, 1906. The *Oregonian* said this streetcar "fared worse in the riot of Saturday night than any other." (Courtesy Norm Gholston.)

The hilly neighborhood in the background would seem to place this picture of brand new car No. 416 on upper Thurman Street. It was in the first group of American Car Company closed trolleys ordered by PRL&P in 1907. Although they were not used this way in Slabtown, this series was equipped with multiple unit (MU) control allowing coupled two-car trains to be operated by a single motorman.

57

St. Vincent's Hospital, Portland, Oregon.

Portland's first permanent hospital opened in Northwest Portland in 1875. Twenty years later, St. Vincent Hospital moved from its original location on Northwest Twelfth and Marshall Streets to the new facility seen here on Northwest Westover Road between Glisan and Irving Streets. The author's mother was born here three years after this 1909 postcard was printed. When the hospital relocated to the suburbs in 1971, it was replaced by condominiums.

Northwest Portland was a center for medical study and treatment in the 19th and early 20th Centuries. Good Samaritan Hospital, seen here on Northwest Twenty-Second and Lovejoy Streets, opened at nearly the same time as St. Vincent's. It offered the first nurses' training school in the Pacific Northwest. Today, patients, staff, and medical students ride streetcars to the modern "Good Sam." (See picture on page 119.) (Courtesy Norm Gholston.)

This *Oregon Journal* advertisement appeared in 1907, six years after streetcar executives Franklin Fuller and Charles Swigert opened the Vaughn Street Ball Grounds. Fans of the ensuing 55 seasons of Beaver baseball owed it all to cooperation between executives from the rival Portland Railway and City & Suburban Railway companies.

BASEBALL

ATHLETIC PARK

Corner Vaughn and Twenty-fourth.

September 5, 6, 7, 8

PORTLAND vs. OAKLAND

Sunday Two Games for One Admission.
Game called at 3:30 p. m. daily.
Games called at 2:30 p. m. Sundays.

ADMISSION 25c

Grandstand 25c. Children 10c.
Box Seats 25c.

Crowds board baseball specials in front of the Vaughn Street Ballpark ticket office on the corner of Northwest Twenty-Fourth Avenue and Vaughn Street during the early 1900s. The first streetcar, with a "Base Ball" roll sign, is a 100-class City & Suburban Standard built at the nearby Savier Street Carbarn, while what looks like a 200-series Portland Railway Fuller open approaches in the background. (Courtesy Norm Gholston.)

59

Forty years after the picture on the previous page was taken, a string of trolleys headed by cars Nos. 553 and 549 await Beaver baseball fans on Northwest Twenty-Fourth Avenue near the Vaughn Street Ballpark. It must be a big game, since Twenty-Third Avenue trippers line both tracks. The dash advertisements promote a dance studio on Southwest Fifth Avenue and Stark Street. (Photograph by Charles Hayden.)

No. 627, resting at Northwest Twenty-Fourth Avenue and Nicolai Streets during the 1930s, is displaying the notched metal "To Ball Game" sign that was attached to the top of regular route signs on game days. The large building in the background is probably part of the Willamette Iron and Steel Corporation, which built geared logging locomotives during the 1920s.

A boy sticks his hand out the window as No. 805 heads north on Northwest Twenty-Fourth Avenue near York Street. A large "Beavers Stadium" sign can be seen on the Vaughn Street Ballpark in the left background of this 1940s scene. The streamlined Brill "Broadway" car is wearing the dark-red-and-cream paint and winged Portland Traction Company logo used during the final years.

This newspaper photograph of Vaughn Street Ballpark was taken on its last day—September 11, 1955. There were no trolleys to carry fans to and from the park. The place where the Red Sox discovered Ted Williams, where the great Joe Tinker first played, that had survived floods and a three-alarm fire, had outlasted the beloved Twenty-Third Avenue streetcars by five years.

No. 623 is waiting at the new Twenty-Third Line terminal on Northwest Twenty-Fourth and Nicolai Streets during the early 1910s. The building behind the streetcar is typical of the commercial enterprises that sprang up at the end of most carlines. It is a general store selling groceries, produce, meat, and even hay. (Courtesy Mark Moore.)

Twenty-Third Avenue car No. 572 is seen downtown on Southwest Washington Street at Fifth Avenue in the later years. The Owl Drugstore is at right, behind a 1930 Studebaker. The sign hanging across the street behind the streetcar is for the Circle Theater. Note the cobblestones between the rails in the street. (McClellan photograph.)

Two Twenty-Third Avenue streetcars are passing at the intersection of West Burnside Street and Northwest Twenty-Third Avenue about 1940. In the background is the sign for Henry Thiele's Restaurant, which replaced the Gambrinus Tavern in 1932. The Murlark Hall Building at right housed the Tha Mar Dance Studio, La Vista Salon, Gambert Cleaners, and Christian Science Reading Room. (Courtesy Mark Moore.)

Time is running out for careworn No. 563 in this view on Northwest Twenty-Seventh Avenue north of Northwest Thurman Street not long before Portland Traction Company retired the car in 1948. The old three-story hotel is in the background. During the last years, the Twenty-Third Avenue Line reverted to using the old fairground loop terminus opened in 1905.

A well-loaded car No. 577 rolls southward at Northwest Irving Street through the Twenty-Third Avenue commercial district. Although the Handy Andy Five & Ten Cent Store next to the trolley is long gone, the old storefronts house fashionable eateries today.

This picture of Twenty-Third Avenue car No. 657 was taken in the summer of 1946 as it trundled across Northwest Northrup Street. The poster on the dash advertises an appearance by Jack Teagarden and his Orchestra at Jantzen Beach. He appeared in the Golden Canopied Ballroom, from which the Armed Forces Radio Service network originated live band remotes for its One Night Stand program during World War II. (McClellan photograph.)

No. 527 is heading west on Northwest Thurman Street near Northwest Twenty-Fourth Avenue in a neighborhood that looked rather sparse in the 1940s. Today, infill has done away with these gardens, garages, and vacant lots.

A dog searches for a snack around two Twenty-Third Line trolleys laying over at the end of the line on Northwest Thurman and Upshur Streets on a hot 1946 day. The advertisement on the dash of car No. 523 promotes Richard Fagan's "Mill Ends" column, which appeared in the *Oregon Journal* through 1969.

Trolley No 523 is on the ladder tracks leading into the old Savier Street Carbarn on Northwest Raleigh Street. Portland Traction Company reduced maintenance costs by painting over window sash and doors that were formerly stained a handsome mahogany color. (Photograph by John F. Bromley.)

Car No. 524 is about to turn the corner at Northwest Thurman Street and Twenty-Fifth Avenue in front of a house that was once a landmark near the northern end of the Twenty-Third Avenue Line. Small Victorian homes like this were popular with Slabtown families because they were affordable and close to work. (McClellan photograph.)

The West Hills peek through the fog as a young woman checks her ticket before boarding city-bound car No. 537 at Northwest Twenty-Third Avenue near West Burnside Street. The Union Service Station property behind the trolley is now part of Northwest Westover Road, but the Twenty-Third Street Garage to the right survives as the Packard Building. (Photograph by Warren Miller.)

Trolley No. 591 has just passed a Divco milk truck from Sunshine Dairy in this 1940s snapshot taken on Northwest Thurman Street. The exact location is undetermined since many small Victorian homes like these have been replaced with condominiums today. Car No. 591, now in the Portland Traction Company's red-and-cream colors, was one of the last 17 PAYE cars.

Car No. 591 is gliding down the hill in front of the Hotel Campbell on Northwest Twenty-Third Avenue and Hoyt Street. The 1912 vintage residential hotel featured a dining room, as can be seen by the arched neon sign above the entrance reading "Hotel Campbell Dining Room." Today, the building is a condominium and the dining room is very much in use as a brewpub. (Photograph by Warren Miller.)

After the Savier Street Carbarn was closed in 1937, streetcars serving the Twenty-Third Avenue Line operated out of the Ankeny Carbarn on the other side of town. In a view looking eastward on Northeast Couch Street near Twenty-Eight Avenue, No. 573 is seen leaving the barn. This site now houses a grocery store.

In August 1948, streamlined "Broadway cars" like 808 and 812 replaced the trolleys that had been used on the Twenty-Third Avenue Line for 40 years. The Stadium Tavern at left went out of business after suffering a 1949 fire. Today, this scene on West Burnside Street at Nineteenth Avenue is nearly unrecognizable since all but the apartments in the background have been replaced by a fast food restaurant. (Courtesy Ken Hawkins.)

Although their numbers have been reduced in recent years, Slabtown was once home to several World War II surplus Quonset huts, like the one seen here. Bob's Fried Chicken provided convenient meals from this prefabricated steel hut on Northwest Twenty-Seventh Avenue and Upshur Street near the northern terminal of the Twenty-Third Avenue carline.

Most things in this scene at the end of the Twenty-Third Avenue Line are preserved today. Thanks to the late Bill Naito, Montgomery Ward is now Montgomery Park. The building housing the Monte Carlo Restaurant (behind No. 808) is still in use, and a streetcar of this type still exists. Sister Broadway car No. 813 has been restored at the Oregon Electric Railway Museum in Brooks, Oregon. (Photograph by John F. Bromley.)

A few streetcar bodies escaped the wrecker's torch, finding alternative uses as chicken coops, storage sheds, beach cabins, and diners. Such was the case with 1909 vintage PAYE trolley No. 560, which still proudly exhibits a roll sign set for Twenty-Third after having found a place in the country upon retirement in 1945.

Five
THE WILLAMETTE HEIGHTS LINE

The third carline to reach Slabtown was the Willamette Heights Line, although it was not called that at first. As readers may remember from the previous chapter, cars on the Twenty-Third Street Line first used that name in 1891, when the Multnomah Street Railway began extending tracks westward on Northwest Thurman Street. There was also a competing Transcontinental Street Railway route on Northwest Savier Street, but it was never labeled Willamette Heights.

As it turned out, the Willamette Heights designation proved temporary for Twenty-Third Street trolleys. In 1907, Depot and Morrison Street Line cars took over service to Willamette Heights. The Depot and Morrison Street Line was an existing line with roots that can be traced back to two horsecar lines: the 1883 G (Glisan) Street Line and the 1886 M (Morrison) Street Line. When it was electrified in 1891, the M Line was running between Union Depot and Southwest Twenty-First and Morrison Streets. Around 1904, it had been extended along a stair-step route through Slabtown to a terminus on Northwest Twenty-Seventh and Thurman Streets on the fairground loop.

By the time PRL&P took over in 1906, the G Line had disappeared and the M Line had become the Depot and Morrison Line (DM). Since it replaced Twenty-Third Street Line service to Willamette Heights, Depot and Morrison Street trolleys now carried a Depot and Willamette Heights dash sign (Depot-W).

On October 14, 1923, the Depot and Morrison Street and W Line was discontinued, and its route was divided between two lines. The Council Crest Line was extended to serve Union Depot, while a new route, now just called the Willamette Heights Line, absorbed the northern portion of the old Depot and Morrison Line.

In addition to linking Heights residents with downtown jobs, shopping, and theaters, the new Willamette Heights Line provided passengers with access to local commercial districts on Northwest Twenty-First Avenue and Northwest Thurman Street, Chapman Elementary School, the Hippodrome Ice Arena, and numerous churches. Willamette Heights Line trolleys operated until service was discontinued on February 26, 1950.

Part of the route that would become the Willamette Heights Line (WH) began as the Depot and Morrison Street Line (DM) in 1907. In that year, the DM Line took over the old Northwest Thurman Street portion of the Twenty-Third Street Line and began running between Union Depot and Willamette Heights as the DM-W Line. DM streetcars had previously turned around on the 1904 fairground loop. In 1923, a new line called Willamette Heights (WH) was created. The Union Depot service was given to the Council Crest Line, and the new WH Line ran from Northwest Thurman and Gordon Streets to a downtown loop on Southwest Washington and Morrison Streets. The southern terminus was changed to Southwest Sherman Street via a second loop on Southwest Sixth and Fifth Avenues three years later. Following the changes brought on by the 1936 franchise, the southern end of the WH run was shortened to loop on Morrison and Washington Streets. That configuration remained in use until all streetcar service was discontinued in 1950.

Until 1903, the streetcar ride along Northwest Thurman Street was divided into two parts, with passengers walking across a wooden bridge over Balch Creek to catch a second car on the opposite side. The flume to the left carried the mud and debris that resulted when large volumes of water were sprayed onto the surrounding hillsides to create flat land for residential development. (Courtesy Norm Gholston.)

A Willamette Heights trolley is seen crossing Oregon's oldest bridge during the 1940s. The Thurman Street Bridge was completed two years before the Lewis and Clark Centennial Exposition of 1905. In her book *Blue Moon over Thurman Street*, author Ursula K. Le Guin explained how this bridge crossed the land claim belonging to Danford Balch, who in 1859 became the first person to be legally hanged in Oregon.

The first streetcars to carry Willamette Heights roll signs were on a branch of the Twenty-Third Street Line, which became the "Washington, Twenty-Third Street, and Willamette Heights Line" in 1894. But, in 1907, service to Willamette Heights was given over to a reconfigured Depot and Morrison Street Line.

This postcard shows a Depot and Morrison Street and W Line Toronto streetcar gliding down tree-lined, but unpaved, Northwest Glisan Street. The picture was taken between Northwest Nineteenth and Twenty-First Streets around 1907. "On the Road of a Thousand Wonders" was a slogan used by the Southern Pacific Railroad to promote the 1,300-mile journey of its Coast Line–Shasta Route trains from Los Angeles to Portland.

New PAYE streetcars were assigned to the Depot and Morrison Street and W Line soon after arrival from the American Car Company in St. Louis in 1908. This close-up view of No. 482 was taken before Nelson Safety Fenders were added in 1912. The car still has its original Portland Railway fender and lacks a retriever, which is a circular spring-loaded device that retrieved the rope if a pole came off the wire.

A "brass hat" (company executive) demonstrates how to exit a PAYE streetcar in this 1908 view of new car No. 467 at the upper end of the Depot and Morrison Street Line. In a prepayment trolley, the conductor stood behind a railing on the rear platform and collected fares from boarding passengers instead of roaming through the car. The exit at the front was controlled by the motorman.

No. 604 is waiting in the rain east of the S-curve in the Blythwood Development at the north end of the Depot and Morrison Line. New houses have not yet obstructed the beautiful view described in the 1911 *Pittmon's Portland Street and Street Car Directory* as "overlooking the Lewis and Clark Fair Grounds." The advertisement on the dash is for a concert at Oaks Park.

The conductor leaning on a switch iron at the northern end of the Depot and Morrison Line is ready to switch from single to double tracks on Rugby Avenue (now Northwest Thirty-Fourth). This long metal pole was inserted into slots in the street to move the tongues of track switches. Switch irons were hung on the dashboard, as can be seen in the previous picture. (Courtesy Mark Moore.)

Four-wheel Birney cars like No. 19 were the first lightweight trolleys. Designed for one-man operation, they were called safety cars due to design features that included a "dead man" control that brought the car to a halt if the controller handle or foot pedal were released. Portland's Birneys were leased from the Emergency Fleet Corporation for use during World War I, although they did not arrive until January 1919.

Car No. 19 and a sister Birney are stored in the Savier Yard in 1936, less than two years before the Savier Division was closed. These cars are painted in Portland Traction gray, green, and cream, but when first seen on the Sixteenth Street and Depot and Morrison Lines, they wore dark-red livery with natural woodwork and gold detailing. The back of the Hotel Repose can be seen in the background.

Four streetcars can be seen passing through the heart of Slabtown in this c. 1920 scene looking east on Northwest Thurman Street at Twenty-Third Avenue. The two buildings on the corner at left are still standing today, although in much remodeled form. The trolley in the foreground, a new Birney Safety Car, has been rerouted, since Depot and Morrison Street Line cars usually

turned on Northwest Twenty-Seventh Avenue. The only line running east from this point would have been the North and South Portland. Otto Hagen's pharmacy can be seen on the right, where the Northwest Regional Library building is today. Across the street is the Ugelsich Grocery. (Courtesy Mike Ryerson.)

After the last Portland Birneys ran on May 23, 1937, most went to Schnitzer Brothers in the Guild's Lake industrial area, which became an important scrap metal source for the Army during World War II. Harold Schnitzer, the fifth of seven children born to Russian immigrants Rose and Sam, transformed the family junk business into the Schnitzer Steel Company.

Willamette Heights car No. 615 has just passed a Westover Line Council Crest–type streetcar on Northwest Northrup Street at Twenty-Third Avenue. To help win public acceptance for one-man operation, No. 615 had been rebuilt as a showcase "safety car" in 1929. Old seats, doors, and fixtures were replaced at a cost $1,000 above the car's actual value. Compare this with the picture of the former Westover Pharmacy building on page 118.

80

Northbound Willamette Heights trolley No. 654, resplendent in Portland Traction apple-green and cream, has paused in front of the Gilmore Gasoline station on Northwest Twenty-First Avenue and Lovejoy Street on a warm 1940s day. The service station with the slogan "Roar with Gilmore" has long since vanished, but the buildings at far right are still a fixture of Twenty-First Avenue. (McClellan photograph.)

Willamette Heights No. 653 is turning east at the intersection of Northwest Nineteenth Avenue and West Burnside Street on its way downtown sometime in the 1940s. It has just passed a billboard on the side of the old Stadium Tavern promoting thrill rides, games, and an appearance by the Jack Teagarden Orchestra at the Jantzen Beach amusement park.

81

Westbound Willamette Heights car No. 524 has just rounded the corner from Northwest Twenty-First Avenue onto Northwest Northrup Street on a late afternoon around 1947. This scene is frequently repeated today when modern trolleys on the Portland Streetcar's NS line glide past the extant building in the background that once housed the Dreller Fuel Company.

The smiling gentleman on the corner is watching inbound car No. 555 as it turns south from Northwest Thurman Street onto Northwest Twenty-Seventh Avenue. This intersection is not much changed today; Bergman's Outdoor Shoe Store in the background is no more, but the brick apartment house and the large home next to it are still in place.

Willamette Heights trolley No. 650 is turning west at the intersection of Northwest Twenty-Seventh Avenue and Thurman Street looking in the opposite direction from the previous picture. The homes in the background are still in use today, as is the commercial building partially seen on the corner, with the billboards for Jack Cody's and a dance studio promising, "Dancing Mistakes We Correct."

No. 657 is headed south past an automotive paint business on Northwest Nineteenth Avenue near West Burnside Street. Today this building is one of the few in the area still housing automobile-related businesses. No. 657 was one of ten cars "modernized" with a combination of cross and longitudinal seating in 1928. It was also one of the handful of streetcars that featured an above-window (instead of roof mounted) roll sign.

One could take a trolley to church, as seen in this snapshot taken on Sunday, October 30, 1949, from the steps of Trinity Episcopal Cathedral at Northwest Nineteenth Avenue and Davis Street. The elegant Victorian homes in the background, once typifying the Nob Hill neighborhood, were knocked down for a parking lot; however, the apartments at right remain. (Photograph by Warren Miller.)

Here, streetcar service will cease in less than six months, but Portland Traction Company No. 524 glistens in an apparently new coat of paint as it runs south on Northwest Twenty-First Avenue at Northwest Kearney Street on sunny September 1, 1949. Saint Mark's Episcopal Church is in the background. Note the brick paving between the rails. (Photograph by Robert T. McVay.)

This view from Willamette Heights shows prominent landmarks in the developing Guilds Lake industrial area including, from left to right, the Forestry Building from the Lewis and Clark Centennial Exposition (1905), the Montgomery Ward Catalog Warehouse and Department Store (1920), and the American Can Company (1921). The "World's Largest Log Cabin" and Montgomery Ward, which included a restaurant and a post office, were Slabtown attractions for decades. (Courtesy Donald R. Nelson.)

In March 1943, trolley No. 615 is seen crossing the Thurman Street Bridge, with Montgomery Ward and the original Forestry Building from the Lewis and Clark Centennial Exposition in the hazy background. The Forestry Building was destroyed in a 1964 fire, but the late Bill Naito remodeled Ward's landmark 1920 mail-order catalog warehouse and department store into an office building and special events center. (Photograph by Warren Miller.)

The operator is leaning out the window to raise the trolley pole from inside one end of No. 595 during a layover at the northern terminus of the Willamette Heights Line. This photograph was taken in the late 1940s, and the trolley is in good shape. The dash advertisement tells customers to "take this car to Windolph Pontiac" at West Burnside and Northwest Nineteenth Streets.

This view of No. 595, taken on September 6, 1948, provides a good idea of how the American Car Company PAYE cars looked inside. Cars Nos. 521–665, built between 1909 and 1911, represented the largest car order and were the streetcars most commonly found in Slabtown. They were 45 feet long, 8 feet wide, and could accommodate 32 passengers on two longitudinal bench seats, with 35 standees. (Photograph by Warren Wing.)

Heavy rain has always brought challenges for Heights residents, as evidenced by this 1950 view of car No. 596 squeezing past landslide repair work onto the single track near the end of the Willamette Heights Line on Northwest Thurman and Gordon Streets. (McClellan photograph.)

Car No.559 is approaching Northwest Northrup Street from Northwest Twenty-First Avenue during the record snowfall that began in January 1950. Most of the buildings seen here, including the Acacia Apartments in the right background, remain today. What is missing is the Hippodrome (curved roof above the storefronts), which was the largest ice skating and hockey rink in the world when it opened in 1914. (McClellan photograph.)

Two Willamette Heights streetcars pass on Northwest Northrup Street between Twenty-Third and Twenty-Fourth Avenues, probably after the same January 1950 snowfall seen in the previous image. No. 561 was one of just 17 PAYE trolleys still in use when service was dropped a month after this picture was taken. The older homes in view no longer exist, but the three-story apartment building in the background is still there.

The snow is still piled high in Wallace Park in this Jack Frost scene looking north on Northwest Twenty-Fifth Avenue at Raleigh Street. Trolley No. 565 is turning on the single track made necessary by the tight radius curve, while an outbound 800-series Broadway car waits in the foreground. Operators preferred the Broadways in snow and ice. (Photograph by Charles E. Hayden.)

Outbound Willamette Heights car No. 591 is approaching Northwest Twenty-Third Avenue on Northrup Street. The old nurses' dormitory at Good Samaritan Hospital on the right remains in place today and so do the streetcars. The modern Portland Streetcar NS line turns south onto Twenty-Third at this same intersection. Note the classic sign designating a "Car Stop" on the telephone pole (McClellan photograph.)

There are only 19 days remaining for streetcars in Portland as trolley No. 596 soldiers through the snow on the corner of Northwest Twenty-Fifth Avenue and Northrup Street on February 7, 1950. The house with the large gables still presides over this corner of historic Slabtown.

No. 555 is seen rolling through the slush past a row of fine Willamette Heights homes that still exist here at Northwest Thirty-Second Avenue and Thurman Street. The advertisement card on the dash tells prospective shoppers that the nearby Montgomery Ward department store is open evenings. (Photograph by Warren Miller.)

Passengers are crowding into the vestibule as Willamette Heights Line veteran car No. 561 trundles between Johnny's Cleaners and the Friendly Tavern on Northwest Twenty-First Avenue at Lovejoy Street on February 24, 1950. In two days, it will be all over for Portland streetcar service.

In another picture taken on February 24, 1950, Willamette Heights car No. 596 is passing two brick apartment houses at Northwest Twenty-First Avenue and Glisan Street that are still there today. In the background are a drugstore and bakery in the Nob Hill commercial district. (Photograph by Warren Miller.)

Passengers on the last Willamette Heights streetcar peer into the camera in this view inside No. 561. Budding traction fan Chuck Hayden is leaning forward fifth from left. When this car rolled to a stop at Northwest Thurman and Gordon Streets, it closed the book on 78 years of streetcar service in Portland.

No. 561 was caught by the flashbulbs as it completed the last run to Northwest Thurman and Gordon on February 26, 1950. The "owl" (the term used for late-night runs) car departed downtown Portland at 12:32 a.m., then returned to the Ankeny Carbarn in Southeast Portland via the Burnside Bridge, while a bus took over Willamette Heights duty.

The late streetcar activist Larry Griffith took this picture of his son Larry Jr. standing on the steps of a soon-to-be-demolished streetcar at the Center Street Shops in Southeast Portland. It is October 1950, and cars Nos. 561 and 555 are lined up for their short trip to oblivion. (Photograph by Lawrence Griffith.)

Six

STUBS AND CROSSTOWN LINES

The last carlines to Slabtown included two stubs and a crosstown line. Stub lines began at the end of another line and were usually built by real estate interests and then donated to the railway company as a means of promoting development in hard-to-reach sites. Crosstown lines connected opposite ends of town. A half dozen lines became crosstowns during the 1910s and 1920s, when lines were combined.

The North and South Portland Line was created around 1896 in what was then "North Portland." It utilized portions of the following two former Transcontinental Street Railway horsecar franchises: the G (Glisan Street) and S (Savier Street) Lines. When the City & Suburban Railway extended the Savier Line into South Portland using rebuilt Metropolitan Railway Company rights-of-way, the resulting route became the S-North and South Portland Line (the "S" was dropped after World War I). As will be seen in chapter seven, a modern NS Line returned in 2001.

The Kings Heights and Westover stub lines were financed by the Dorr Keasey real estate syndicate. The line to Kings Heights opened in June 1911, with an extension to Mount Calvary Cemetery, actually a stub on a stub, from the Northwest Hermosa Boulevard and Valle Vista Terrace to the cemetery. The extension was operated for the United Railways Company until abandonment in 1927 due to poor track. The Kings Heights development was named for Amos N. King, one of the original donation land claim owners in Northwest Portland.

The last line built in Northwest Portland was the Westover stub, which inaugurated service in July 1913. Westover streetcars ran from a connection with the Depot and Morrison Street Line at Northwest Twenty-fifth and Pettygrove Streets to Cumberland Road in the Westover Terraces development. In 1930, Westover streetcars began running to downtown during off-peak hours.

The crosstown North and South Portland Line stopped running May 23, 1937. Trolley service on the stub lines lasted five more years, until 1941. On August 24, the Arlington Heights (in Southwest Portland), Kings Heights, and Westover trolleys were replaced by a single bus line.

The North and South Portland Line operated on trackage built by several pioneering railway companies beginning with the Transcontinental Street Railway's S (Savier) Street horsecar line. The S Line broke ground in 1883 and reached Savier Street around 1887. In 1889, it was extended to Northwest Twenty-Fourth and Thurman Streets. Successor City & Suburban Railway electrified the line during 1891–1892, and not long afterward, the long Third and S Streets Lines were linked to become the S-North and South Portland Line. Around 1900, the southern terminus was changed from First and Whitaker Streets to Hamilton and Corbett Streets. During the 1905 Lewis and Clark Centennial Exposition, North and South cars were rerouted to the fairground loop, which they returned to again in 1910. In the interim, the northern terminus was Northwest Twenty-First and Sherlock Streets. The S-NS abbreviation became just NS during World War I, a designation that was returned to use by Portland Streetcar (see chapter seven). In 1923, NS cars took over the Fulton Line's route to Riverview Cemetery. The line continued running between the fairground loop and the cemetery until conversion to trolleybus in 1937.

This early view on the North and South Portland Line shows the Northwest Sherlock and Twenty-First Streets terminal that was in use between 1905 and 1909. Multiple unit (note MU receptacle next to headlight) equipped car No. 416 was built by the American Car Company in 1907. The three-story rooming house and restaurant in the background survived until 2014, as the surrounding neighborhood became more industrialized.

None of the hotels and boardinghouses built close to the ends of Slabtown streetcar lines looked more interesting than the Forestry Inn, seen under construction on Northwest Upshur and Twenty-Fifth Streets. The March 1, 1905, *Oregonian* announced that a group of investors planned to open this "rooming and eating-house." It was obviously inspired by the nearby Forestry Building at the Lewis and Clark Centennial Exposition. (Courtesy Norm Gholston.)

What looks like a horrible accident on Northwest Thurman and Twenty-Sixth Streets is actually a 1912 safety training exercise using a dummy. After a demonstration by inventor F.A. Nelson of Minneapolis, the city council passed a resolution requiring these Nelson Safety Fenders on all streetcars. The Fairmount Hotel in the background was built as an accommodation for visitors to the 1905 Lewis and Clark Centennial Exposition. (Courtesy Mark Gilmore.)

The carmen are squinting into the sun in a picture taken on Northwest Upshur Street around 1913. The building in the background may be the Outside Inn, which was across the street from the Fairmount Hotel. It featured a restaurant and shops on the main floor. No. 610 was in the last car order from the American Car Company in 1911. (Courtesy Mark Moore.)

North and South Portland car No. 527 is thought to be on Northwest Glisan near Ninth Avenue in this photograph taken about 1912. North and South Portland Line streetcars carried a depot dash sign since they passed the North Bank Station and were one block from Union Depot as they ran along Northwest Glisan Street. The dash advertisement is for a band concert at Oaks Park. (Courtesy Mark Moore.)

Large numbers of candy basket–toting carmen turned out on Northwest Glisan Street in the North Park Blocks to support their candidate for 1914 Rose Festival Maid of Honor. Alice Husby, seen riding in the lead automobile, was cosponsored by the PRL&P Electric Club and the Made in Oregon Club (whose car is following). The Honeyman Hardware warehouse visible in the background survives today as condominiums.

No. 610 could be at either end of the NS Line in this photograph; laying over on Northwest Twenty-Seventh and Upshur Streets on the Fairgrounds Loop, or on Southwest Taylor's Ferry Road adjacent to Riverview Cemetery. The call box mounted on the telephone pole in front of the pristine hills in the background contained a telephone used by the conductor for reporting in to the dispatcher at the end of a line.

The motorman and conductor pose with their streetcar at what was then the North Portland end of the line, next to the hotel on Northwest Twenty-Seventh and Thurman Streets. The safety fender and fancy pinstriping on No. 619 mean this picture was taken during the 1910s.

These inbound and outbound North and South Portland Line transfers grouped points at which passengers could change lines into a dozen categories, such as "W of 21st & Th'man, WA-S to 13-S, MT-S at 11th." Translation is west of Northwest Twenty-First and Thurman riders could transfer to southbound Williams Avenue cars (on Northwest Glisan), or at Southwest Eleventh Avenue, they might transfer to southbound Mount Tabor cars.

Car No. 621 is displaying a North Bank Station dash sign. The station served trains of the Seattle, Portland and Spokane Railroad and the Oregon Electric Railway. It was built in 1908 at Northwest Tenth and Glisan Streets, four blocks from Union Depot, which was used by competing Southern Pacific trains. See the picture of modern streetcars passing the former North Bank Depot on page 124. (Courtesy Donald R. Nelson.)

The dash signs help date this picture of No. 623 on Northwest Twenty-Seventh Avenue between Thurman and Upshur Streets. "NS Fulton" means it was taken after 1923, when the Fulton Line was merged into NS, making Riverview Cemetery the new southern end of the line. Two silent films are advertised on the dash poster: *Manicure Girl*, starring Bebe Daniels (1925), and comedy short *Hello Bill*, starring Billy West (1923).

Like other Heights lines, the King Heights stub was financed by real estate interests, then turned over to PRL&P for operation. It opened in 1911 over a route featuring curved trestles and private rights-of-way. Portions of the extension to Mount Calvary Cemetery were originally surveyed for a branch line to the long-defunct Barnes Heights & Cornell Mountain Railway. The Mount Calvary extension was bused in 1927, with Kings Heights following in 1941.

Carmen far outnumber passengers in this image of No. 464 at the western terminus for the Kings Heights Line on West Burnside Street near Northwest Twenty-Third Street. This was close to one of the entrances to City Park as well as the Gambrinus Brewery and the Washington Street Carbarn. Toronto-type car 464 was a 1902 product of the rival carbarn on Savier Street. (Photograph by Cal Calvert; courtesy Mark Moore.)

Transportation Club members are dutifully watching the birdie as No. 300, the observation car "Seeing Portland," stops for a panoramic view from King Heights in 1912. Traffic manager Frank D. Hunt (standing by the trolley) is tour director. The car had 14 cross bench seats accommodating 56 passengers. The City & Suburban Railway built it in 1904 with four motors and magnetic brakes for hills. (Courtesy Mark Gilmore.)

THE OBSERVATION CAR

THE above excellent illustration shows the "Observation Car" of the P. R., L. & P. Co. This car twice a day gives the visitor a *twenty* mile journey through the city and to the various points of interest. It does not confine itself to the narrow scope of the customary sight-seeing route, but goes far beyond the points touched by automobile sight-seeing journey. It visits Council Crest Park—the topmost point of the range of mountains to the west of the city. It ascends King's Heights, another high point where the country can be viewed for miles. Both points are famous throughout America. Anyone visiting Portland need only inquire of the first person he meets, as to the most wonderful sight in Portland, and he will be told that the view from Council Crest is unexcelled in this country, and in only one place in Europe can be found to compare with it, that being Buda-Pest, Austria.

Council Crest: Here a delightful park is found and the view is world famous. Snow capped peaks, the Columbia and Willamette rivers, and before the eye is spread a birdseye view of the entire city of Portland; to the west is the beautiful Tualatin valley.

Down Town District: The Observation Car passes all of the important public and private buildings. The lecturer on the car will point out each one.

The East Side: Here the car passes through a new business district and some of the prettiest residences of the city.

Crosses Bridges: The passenger will be taken across the Willamette river at two different points and a full view of the shipping interests is obtained.

Hotel and Theatre District: The car goes right through all of this section of the city.

Nob Hill: Here in the west end of the city are to be found the palatial homes of the wealthy people of Portland.

Forestry Building: This building was constructed during the Lewis and Clark fair. It is one of the wonders of the world.

Willamette Heights: Here a view is obtained from a high point of the upper Willamette country.

King's Heights: Another view which is unsurpassed, except by Council Crest.

Portland Heights: These Heights are only half way in the journey to Council Crest. While the view is beautiful it is several hundred feet beneath that obtained further up. The Observation Car passes through the principal residence section of the Portland Heights and in doing so the passenger secures many views of different angles in the journey of ascending the mountain, so as to reach the gem of the Pacific Coast from a scenic standpoint—Council Crest.

Twenty Mile Ride ∞ 50 Cents ∞ Tickets at all Hotels

PRL&P offered trolley tours of interesting and scenic Portland sights into the 1920s. Ten areas are highlighted in this brochure for the "Seeing Portland" observation car, which left twice a day for 20-mile trips that "go far beyond the points touched by automobile sight-seeing journey." Choice residential neighborhoods, as well as business and theater districts, were covered. Northwest Portland is well represented in the high points outlined here, including Nob Hill, the Forestry Building, Willamette Heights, and Kings Heights. Kings Heights is described as offering views that are unsurpassed except at the higher elevation Council Crest. Tickets were 50¢ and were available "at all hotels." Special cars, accompanied by a lecturer, were also available for private charter. (Courtesy Mark Moore.)

Kings Heights Line trolley No. 464 is approaching the terminus at Mount Calvary Cemetery in the 1910s. The Archdiocese of Portland established the cemetery in 1888. The ill-fated Barnes Heights and Cornell Mountain Railway had been the first railway company to reach this point in 1892, but the Financial Panic of 1893 ended its dreams of a line to Hillsboro and a connection to Portland Consolidated Railway trolleys in Willamette Heights.

No. 459 is negotiating a tight curve as it emerges from private right-of-way on the Mount Calvary Line. Portions of this line used roadbed that is said to have been surveyed for the Barnes Heights & Cornell Mountain Railway, whose steep 2.5-mile line up the Barnes Road Canyon to the cemetery operated sporadically between 1893 and 1896. The author has never seen a photograph of that railway.

103

Mists hang in the trees above car No. 460 as it climbs a long-vanished private right-of-way on the Kings Heights Line. This may be a short off-road section from Northwest MacLeay Boulevard, since the scenic extension to the cemetery had been discontinued several years before this picture was taken in the 1930s. Deteriorating track caused the abandonment of the cemetery extension in 1927.

Both poles are up, meaning the operator on No. 460 was in the process of changing ends when this picture was taken at the western Kings Heights Line terminus on Northwest Hermosa Boulevard at Valle Vista Terrace. Today, the long driveway to a modern home takes up the area marked by the elaborate stone terracing seen in the background and a hiking trailhead begins at the end of the pavement.

Toronto No. 454 has arrived at the Northwest Twenty-Third Avenue and West Burnside Street terminus for both the Kings Heights and Arlington Heights Lines. The former Washington Street Carbarn buildings that stood at this location are gone, having been recently demolished when this late 1930s photograph was taken. With the exception of a grocery store and parking lot, the view looks much the same today. (Photograph by Warren Miller.)

No. 460 is at West Burnside and Northwest Twenty-Third Avenue next to Henry Thiele's Restaurant. Buildings that were once part of Gambrinus Brewery are in the background. The red tile and white stucco eatery, built in 1932, was demolished in 1995 to make way for a shopping center named for the well-known German chef. Compare this with the previous picture looking in the opposite direction at the same intersection.

105

PRL&P began service over the Westover Line on July 13, 1913. The stub line originally operated from a connection with Depot and Morrison Street Line cars at Northwest Twenty-Fifth and Pettygrove Streets to Northwest Aerial Terrace and Cumberland Road. Shortly after its inauguration, the eastern terminal was changed to Northwest Twenty-Third and Northrup Streets, where passengers could transfer from Twenty-Third Avenue trolleys. Beginning on June 16, 1927, through service to Southwest Fifth and Sherman Streets operated during rush hour. In February 1930, Westover cars began off-peak operation to Southwest Fifth and Jefferson Streets, while continuing to Southwest Fifth and Sherman during the morning and evening rush. Conflicting sources indicate the final portion of the line ended on Northwest Cumberland Road at Shenandoah Terrace rather than Aerial Terrace, but this might also indicate a later cutback. On January 24, 1938, service to downtown was again reduced to rush hours only. On October 23, 1938, following the closure of the Savier Division, Westover cars began operating out of the Piedmont Carbarn. The line was discontinued on August 23, 1941.

A Westover Line Toronto-type streetcar is seen eastbound on Northwest Cornell at Westover Road in the early 1920s. The Tudor-style home on the corner is still there today. It was built in 1912 for W.C. Morse, vice president of the Lewis-Wiley Hydraulic Company responsible for reconfiguring Goldsmith Hill to form Westover Terraces. Guild's Lake, in the background, has already been partially filled. (Courtesy Donald R. Nelson.)

Westover Line car No. 456 is passing the pharmacy on the corner of Northwest Northrup Street and Twenty-Third Avenue. The Westover Pharmacy was a traditional family-run drugstore with a fountain. The building in the background is the nurses' quarters at Good Samaritan Hospital. (McClellan photograph.)

The operator on car No. 454 is working alone as he gets ready to change ends at the western terminal for the Westover Line on Northwest Cumberland Road and Ariel Terrace. The Westover run was converted to one-man operation earlier than most, on November 5, 1917. The house in the background remains a part of the neighborhood today.

The beautiful woodwork and spindled seats in trolley 460 are a testament to local craftsmanship. The Toronto-style car was built at the Savier Carbarn in 1902. Note the poster on the window advertising *The Milky Way*, a 1936 movie starring Harold Lloyd that was playing "Every Thur-Fri-Sat in May." Admission to this Depression-era comedy was 10¢ for children and 40¢ for adults.

In 1927, when the line to Westover Terraces was upgraded from a stub to a regular run, trolleys began running through downtown Portland to terminate on Southwest Fifth Avenue and Sherman Street. Westover car No. 457 is seen here rolling westward past the Hotel Commodore on Southwest Seventeenth Avenue and Morrison Street in the late 1930s.

Council Crest–type car No. 510 is westbound between Northwest Twenty-Third and Twenty-Fourth Avenues on Northrup Street, an unusual site for the Westover Line, which was usually served by Nos. 454–457 Toronto cars. Those beautiful Victorian homes next to the streetcar are gone today, but the three apartment buildings at the end of the block remain.

Council Crest Line veteran No. 510 (fender slogan "See Portland from Council Crest") is headed south through foreign territory at Northwest Twenty-Fifth Avenue and Northrup Street on the Westover run. Craftsman-style, three-story apartment houses like the one behind the streetcar are still symbolic of Slabtown. (Courtesy Warren Wing.)

Car No. 510, normally seen on the Council Crest Line, is displaying a Westover roll sign at what looks like the Willamette Heights terminus, so this picture may have been taken on a fan trip during the last weeks of operation. As explained in the next chapter, trolleys that looked like this reappeared in Slabtown in 2001. The dash advertisement is for a Memorial Day rally by evangelist Dr. Chas E. Fuller.

The windows are down as car No. 455 trundles eastward on Northwest Northrup Street on a warm day in the last years of service. No. 455 was one of six Torontos remodeled as single-compartment cars (without closeable vestibule doors) when the Westover Line was upgraded from a stub service to run through to downtown in 1927. This part of Slabtown near Good Samaritan Hospital is now given over to clinics and offices.

No. 453 and a sister Toronto sit next to No. 269 in the Savier Yard. It is July 15, 1936, and all are out of service as plans are made to convert the Savier Division to trolley coach operation. The rarely seen "Lovejoy" roll sign on the second trolley was for a rush hour "tripper" (meaning cars that turned back part way along the line) service on the Twenty-Third Avenue Line.

111

When the Savier Division closed in the summer of 1938, rolling stock required for the Westover Line was kept at the Piedmont Carbarn in North Portland. Old-timer No. 456, signed for duty on the Westover run, is seen here around 1940 in the yard next to the carbarn on North Jessup Street between Mississippi and Michigan Avenues.

It is late afternoon, and the lawn sprinklers are going as Westover Line car No. 457 rolls past a house on Northwest Pettygrove Street across from Wallace Park. Hipped-roof, Dutch Colonial–style homes like this were very popular in the 1930s, the last full decade for the streetcar, and this neighborhood is dotted with them. (Courtesy Ed Culp.)

Inbound WO trolley No. 457 is turning from Northwest Pettygrove Street onto Twenty-Fifth Avenue between a three-story brick apartment building and another classic gambrel roofed home. Both residences are still extant today, but the streetcar line had only two weeks left to go when this photograph was taken on August 8, 1941. (Courtesy Mark Moore.)

In this newspaper clipping from Saturday evening, August 23, 1941, motorman Frank Dorrigan is shown at the helm of Toronto No. 457 "as he piloted the old car up and down the west hills for the last time." The next day, three Heights streetcar routes, Arlington Heights, Kings Heights, and Westover, were taken over by a single bus line.

113

Kings Heights and Westover streetcars ceased running before students returned to school in 1941. By the time this student identification card was issued in December, there were fewer trolleys to catch. However, America's sudden entry into World War II halted further carline abandonments. Reductions for the eight remaining lines would not begin again until 1948.

There was life after retirement for No. 453, which briefly avoided the scrapper's torch when it was pressed into service as the Women's Personnel Office at the Center Street Shops in Southeast Portland during World War II. This was something of a historic role, since women had not been traction company employees prior to that time.

114

Seven

Streetcars Return to Slabtown

Trolleys were popular in Slabtown, which was served by two of the last lines in Portland. Yet, when streetcar operation ceased on February 26, 1950, few expected to see steel wheels rolling again on city streets.

One exception was the late William "Bill" Naito, a prominent Japanese-American businessman who began promoting a heritage streetcar line in Northwest Portland during the 1970s. The idea gained support from the Tri-County Metropolitan Transportation District of Oregon (TriMet) in 1979, as rights-of-way through Old Town were being planned for the Metropolitan Area Express (MAX). When Vintage Trolley Inc. (VT) was formed in 1987 to manage the heritage streetcar operation, Bill Naito was named president. By 1990, he was also a member of the Central City Trolley Committee, which was planning a much larger system.

Faced with a shortage of local trolleys, Naito began importing historic streetcars from Portugal and Australia for use in Old Town. When TriMet engineers found problems with using vintage equipment on light rail lines, Naito arranged for replicas, patterned after the Council Crest cars, to be manufactured by the Gomaco Company in Iowa. VT returned traditionally styled streetcars to Portland on November 29, 1991.

The Central City Trolley idea became the Portland Streetcar, under whose auspices the city launched a "Streetcar Renaissance" on July 20, 2001. VT joined forces with them, providing two trolleys for mixed operation over the new line between the University District in Southwest Portland and Northwest Twenty-Third Avenue, while its other two trolleys continued to share tracks with MAX.

The arrangement with Portland Streetcar ended in 2005, when management decided not to use VT trolleys on a steeper new extension. This was followed by abandonment of all VT operations in July 2014, and the sale of two cars to the St. Louis Loop Trolley. The good news is that the two trolleys used on Portland Streetcar were transferred to the Willamette Shore Trolley Line in Lake Oswego.

In the meantime, Portland Streetcar continues to expand. In 2015, the Central Loop Line will begin using the new Tilikum Crossing Bridge across the Willamette.

In January 1976, radio station KKSN general manager Bill Failing, transportation activist Betty Merten (who is credited with helping kill the Mount Hood Freeway), and Oregon Electric Railway Historical Society secretary Larry "Doc" Griffith formed the nonprofit Willamette Traction Ltd. to lobby for the creation of a heritage trolley operation through Portland's Old Town. During the 1980s, as the Old Town Trolley concept morphed into Vintage Trolley, promotional efforts continued, including artist Don McIntyre's limited-edition poster (seen here), Bill Failing "shamelessly plugging the idea" on his radio station, and Doc Griffith presenting slide programs to anyone who would listen. Meanwhile, enthusiastic supporter Bill Naito began searching for old streetcars to use on the line.

In the early 1990s, two foreign streetcars were stored in a building across the street from Montgomery Park. Hong Kong No. 12 and Porto No. 178 (renumbered No. 819 in Portland) belonged to Bill Naito, who first proposed the idea of operating heritage streetcars in the early 1970s and was later a founder of Vintage Trolley. No. 12 is now at the Oregon Electric Railway Museum in Brooks. (Photograph by Steve Morgan.)

On August 16, 1991, a ceremony was held on the Northeast Eleventh Avenue spur celebrating the arrival of the first Vintage Trolley (No. 511 draped) from Iowa. Officials in view include, from left to right, Eva Friedman, manager of Zell Bros Jewelers; city commissioner (now US congressman) Earl Blumenauer; Bill Naito; TriMet general manager Tom Walsh; Lloyd Center manager Larry Troyer; and VT board member Bill Failing. (Photograph by Steve Morgan.)

Car No. 514, seen turning from Northrup Street onto Twenty-Third Avenue on January 28, 2001, is making the first trip by a streetcar over Slabtown rails since 1950. The new Portland Streetcar Line was ready for testing, but delivery of modern Skoda-Inekon streetcars did not begin until April, so Vintage Trolley No. 514 had the honor of carrying out all the initial testing of newly completed track sections. (Photograph by Steve Morgan.)

Vintage Trolley No. 514 is turning onto Northwest Lovejoy Street from Twenty-Third Avenue during the first powered test trip by any streetcar on the Portland Streetcar Line, January 28, 2001. The Vintage Trolleys are replicas of Portland Brill Council Crest cars of 1904 that were built in 1991–1992 by the Gomaco Trolley Company in Iowa. They use PCC-type trucks assembled from scrapped Boston and Chicago cars. (Photograph by Steve Morgan.)

Vintage Trolley passenger service on the Portland Streetcar Line began on July 28, 2001, using car No. 514 (car No. 513 was not moved to the new line until September). This view along future Northrup Street east of Eleventh Avenue, taken in October 2001, shows a section of the line that had previously been occupied by rail yards. In the distance, the 1913-built Broadway Bridge is open for a ship. (Photograph by Steve Morgan.)

VT No. 513 and chartered streetcar No. 005 are seen eastbound at the Good Samaritan Hospital stop on Northwest Lovejoy Street at Twenty-Second Avenue during an Electric Railroaders Association convention trip on July 4, 2002. The No. 513 crew were longtime volunteer Bill Binns (in front of the trolley) and operator Bill Wegesend. Steve Morgan, who helped organize the excursion, is on the sidewalk in front of the Skoda streetcar. (Photograph by Mark Kavanagh.)

This map showing historic sites along the Portland Streetcar Line appeared on the vintagetrolleys.com website from 2001 to 2008. Vintage Trolley shared tracks with what is now Portland Streetcar's North South Line. The historic sites were: 1. Old Lincoln High School (1911), 2. Simon Benson House (1900), 3. Portland Art Museum (1938), 4. Central Library (1913), 5. Galleria (now City Target, 1910), 6. Governor Hotel (1909), 7. Pittock Block (1909), 8. Armory (1889), 9. McCracken Rapid Transfer (1895), 10. Portland Cordage Company (1887), 11. Portland Streetcar Carbarn (2001), 12. Wells Fargo Stable, 13. American Inn (1905), 14. Legacy Good Samaritan Hospital, 15. North Bank Depot (1908), 16. Pacific Coast Biscuit Company (1891), 17. Weinhard Brew House (1904), 18. Old Elks Temple (1922), 19. First Baptist Church (1894), 20. Calvary Presbyterian Church (1882), and 21. St. Michael Church (1894). Portions of track originally used by the Willamette Heights, Twenty-Third Avenue, and Montgomery Street Lines and the Oregon Electric Railway are also shown.

After Vintage Trolley ceased operation on July 6, 2014, cars Nos. 513 and 514 were transferred to the Willamette Shore Trolley for use on the historic Portland–Lake Oswego "Shore Line." The first of these, car No. 514, is emerging from the Elk Rock Tunnel during testing on April 15, 2013, with Supt. Hal Rosene at the helm. After having been overhauled and repainted, it entered service August 16, 2014. (Photograph by Wayne Jones.)

This January 2001 construction view for the new Portland Streetcar Line looks west on what will soon be Northwest Lovejoy Street from Eleventh Avenue. Until the late 1990s, this entire area was occupied by railroad yards, and Lovejoy Street passed over it on a viaduct that extended from Fourteenth Avenue to the Broadway Bridge. The buildings on both sides of the street are also newly under construction. (Photograph by Steve Morgan.)

Car No. 005 is at Northwest Twenty-First Avenue and Northrup Street during the opening parade for the Portland Streetcar system on July 20, 2001. The first five Portland Streetcars proceeded at moderate speed from Portland State University all the way to Northwest Twenty-Third Avenue, with a marching band in the lead and dignitaries on board the first two cars. Note people watching at left, and escorts marching alongside the car. (Photograph by Steve Morgan.)

The five modern, low-floor Skoda-Inekon streetcars, which opened the Portland Streetcar Line in July 2001, began to arrive in April. The first was No. 001, pictured westbound on Northwest Northrup Street at Nineteenth Avenue during a May 7 training run. Each of the modern streetcars uses a two-color paint scheme, and there are several different combinations for different cars. Car No. 001 is jade green and dark blue. (Photograph by Steve Morgan.)

Skoda-Inekon car No. 004 is westbound on Nothwest Northrup Street at Twentieth Avenue on July 22, 2001. This was the third day of the opening weekend (Friday–Sunday) of the Portland Streetcar Line, and car No. 004 is wearing one of the decorative wreaths that all of the cars wore during the first few days of service, in honor of the line's opening. (Photograph by Steve Morgan.)

Car No. 002 is passing the old Portland Iron Works Building on Northwest Northrup Street between Northwest Twelfth and Thirteenth Avenues in 2001. Established in 1882, the Portland Iron Works produced sawmill and power transmission machinery, as well as ripsaws, edgers, trimmers, and floor and roof drains. Compare this with the original works building in chapter one. (Photograph by Steve Morgan.)

Car No. 004 is passing the old North Bank Depot on Northwest Eleventh Avenue at Hoyt in 2002. The two matching depot buildings were built as freight houses by the Spokane, Portland, & Seattle (SP&S) Railway in 1908, but the east building (seen here) was also used as a passenger station by the SP&S and Oregon Electric Railway until 1931. Interurbans reached it via track on Northwest Tenth Avenue. (Photograph by Steve Morgan.)

In December 2008, Portland experienced its heaviest snowfall in 40 years. Car No. 008 is southbound on Northwest Eleventh Avenue at Johnson Street, next to Jamison Square on December 22. The two Art-Deco totem poles in the background are actually decorative covers for traction poles holding up the overhead trolley wire. Number No. 008 was one of three model 12-Trio cars purchased in 2006 from Inekon Trams. (Photograph by Steve Morgan.)

"James Bond" car No. 007 is turning from Northwest Twenty-Third Avenue onto Lovejoy Street; compare this to the picture of Vintage Trolley No. 514 on page 118 taken from Lovejoy Line. No. 007 was one of two additional cars delivered to Portland Streetcar in 2002. Streetcars on the old Twenty-Third Avenue Line passed through this same intersection until 1950 but did not turn. (Photograph by Steve Morgan.)

The Portland Streetcar system opened its second line, the Central Loop Line, on September 22, 2012, and it passes through the Pearl District next to Slabtown. In this opening-day scene, car No. 010 (a 2006 Inekon 12-Trio) is pulling up to the packed stop at Northwest Ninth Avenue and Lovejoy Street, headed for the east side, while car No. 001 (a 2001 Skoda-Inekon 10-Trio) is passing, westbound. (Photograph by Steve Morgan.)

Streetcar manufacturing returned to Oregon in the 2000s, albeit not in Slabtown, with the establishment of United Streetcar by Clackamas-based Oregon Iron Works. Car no. 015, seen in 2015 pulling up to the stop on Northwest Twenty-Third Avenue and Marshall Street with "Made in the USA" lettering along its sides, was built in 2009 as the prototype United Streetcar vehicle. (Photograph by Steve Morgan.)

The first production-series United Streetcar car to enter service (in June 2013) was number No. 021, which is seen passing the Streetcar Lofts at Northwest Eleventh Avenue and Lovejoy Street on the CL (Central Loop) Line on January 10, 2015. The Fremont Bridge looms through the mist in the background on this typically rainy day. (Photograph by Steve Morgan.)

INDEX

Birney streetcars, 41, 52, 77, 79, 80
City & Suburban Standards, 39, 49, 59
City & Suburban Railway Company, 8, 21, 24, 32–35, 37–39, 49, 59, 93, 101
Council Crest streetcars, 41, 42, 80, 110, 115, 118
Depot and Morrison Line, 53, 54, 71, 72, 74–78, 79, 93, 106
Failing, Bill, 116, 117
First Portland trolley fatality, 17
Fuller streetcars, 27, 28, 39, 47, 52, 55, 59
Fuller, Franklin I., 8, 27, 56, 59
G Street Line, 9, 13, 14, 71
Gambrinus Brewery, 14, 27, 28, 53, 63, 101, 105
Good Samaritan Hospital, 14, 53, 58, 89, 107, 111, 119, 120
Griffith, Larry, 92, 116
Hand Manufacturing Company, 8, 23–25
Holladay, Ben, 9
Kings Heights Line, 28, 93, 101–105, 113
Labor demonstrations, 56, 57
Lewis and Clark Centennial Exposition, 8, 44, 46, 47, 54, 55, 76, 85, 94–96
Low's Adjustable Streetcar, 14, 15, 45
Montgomery Ward/Park, 70, 85, 90, 117
Mount Calvary Cemetery, 100, 103
Multnomah Street Railway Company, 9, 12, 14, 16, 18, 20, 22, 26, 44, 53, 54, 71
Murlark Hall, 29, 63
Naito, Bill, 70, 85, 115–117
North and South Portland Line, 35, 44, 78, 79, 93–100
North Bank Station, 97, 99, 120, 124
North Pacific Manufacturing, 8, 21, 22
PAYE cars, 8, 30, 41, 49, 52, 67, 70, 75, 86, 88
Portland Bronze & Crucible Steel Company, 8, 21
Portland Consolidated Railway Company, 24, 27, 29, 46, 103

Portland Consolidated Street Railway Company, 18, 23
Portland Cordage Company, 13, 120
Portland Railway Company, 8, 15, 18–21, 26, 27, 38, 39, 44, 45, 47, 48, 59
Portland Railway, Light & Power Company, 19–21, 56
Portland Street Railway Company, 9–11
Portland Traction Company, 12, 25, 27, 52, 61, 63, 66, 67, 77, 81
Pullman streetcars, 17, 31, 33–35, 45
Riverview Cemetery, 94, 98, 100
Rose Festival, 52, 97
S Street Line, 9, 13, 17
Savier Street Carbarn, 7, 8, 21, 31–39, 41, 42, 59, 66, 68, 108
Schnitzer, Harold, 80
Seeing Portland car, 8, 39, 101, 102
Sixteenth Street Line, 9, 12, 15, 43–52, 77
Sprague, Frank J., 26, 43
St. Vincent Hospital, 58
Stadium Tavern, 69, 81
Swigert, Charles F., 8, 59
Thiele, Henry, 63, 105
Thurman Street Bridge, 53, 54, 73, 85
Toronto-type streetcars, 28, 33, 35, 39, 41, 74, 101, 103–105, 107–109, 111–113
Transcontinental Street Railway Company, 9, 13, 21, 31, 32, 71, 93, 94
Twenty-Third Street Line, 14, 53–55, 62–70
Vaughn Street Ballpark, 8, 59–61
Washington Street Carbarn, 21, 25, 26, 29, 30, 47, 55, 101, 105
Washington Street Line, 11, 12, 43, 45, 54
Weidler, George, 7, 9
Westover Line, 80, 106–114
Westover Pharmacy, 80, 107
Willamette Heights Line, 52, 54, 71–74, 87, 90

Discover Thousands of Local History Books Featuring Millions of Vintage Images

Arcadia Publishing, the leading local history publisher in the United States, is committed to making history accessible and meaningful through publishing books that celebrate and preserve the heritage of America's people and places.

Find more books like this at
www.arcadiapublishing.com

Search for your hometown history, your old stomping grounds, and even your favorite sports team.

Consistent with our mission to preserve history on a local level, this book was printed in South Carolina on American-made paper and manufactured entirely in the United States. Products carrying the accredited Forest Stewardship Council (FSC) label are printed on 100 percent FSC-certified paper.

MADE IN THE USA